HEY SKY,

I'M ON MY WAY

PUBLISHED BY LIT RIOT PRESS, LLC
BROOKLYN, NY
WWW.LITRIOTPRESS.COM

BOOK AND COVER DESIGN BY ILU ROS.

LIBRARY OF CONGRESS CATALOGING-IN-PUBLICATION DATA.

NAMES: ROS, ILU
TITLE: HEY SKY, I'M ON MY WAY: A BOOK ABOUT INFLUENTIAL WOMEN/ILU ROS.
DESCRIPTION: INCLUDES BIBLIOGRAPHICAL REFERENCES.
IDENTIFIERS: ISBN 9780999294383 (PBK.)
SUBJECTS: LCSH: RIGHTS OF WOMEN. |WOMEN--CIVIL RIGHTS. |WOMEN-- RIGHTS OF WOMEN.| WOMEN'S RIGHTS--LAW AND LEGISLATION.| BISAC: ART/WOMEN ARTISTS. |ART/SUBJECTS & THEMES/GENERAL.|BIOGRAPHY & AUTOBIOGRAPHY/WOMEN. |HISTORY / WOMEN. | YOUNG ADULT NONFICTION/ART/GENERAL. | YOUNG ADULT NONFICTION/ BIOGRAPHY & AUTOBIOGRAPHY/WOMEN. |ART /INDIVIDUAL ARTISTS/MONOGRAPHS
CLASSIFICATION: LCC LB1139.35.A37.R103 2018 (PRINT)

HEY SKY, I'M ON MY WAY

.....................

a book about influential women

by
ilu ros

TO MY PARENTS, WHO GAVE ME THE CHANCE TO CHOOSE.

"EVERY TIME WE LIBERATE A WOMAN, WE LIBERATE A MAN"

-MARGARET MEAD-

TABLE OF CONTENTS:

INTRODUCTION

"HEY SKY, I'M ON MY WAY" IS AN ILLUSTRATED BOOK ABOUT WOMEN WHO HAVE BEEN INFLUENTIAL THROUGHOUT HISTORY. THE NOTABLE WOMEN IN THIS COMPILATION CHOSE ME, THEY GRABBED MY ATTENTION, THEY INSPIRE ME. SOME OF THE WOMEN ARE WELL-KNOWN, SOME OBSCURE, SOME LOST TO HISTORY. THEIR STORIES ARE TRANSFORMATIVE AND INTENSELY MOVING.

EVERY TIME I READ A HISTORY BOOK I FEEL LIKE I AM READING A FANTASY NOVEL IN A WORLD THAT IS DOMINATED BY MEN. MALE HEROES HAVE ALL SORTS OF SURREAL AND ACTION PACKED ADVENTURES BEFORE THEY COME TO THE RESCUE OF THE BEAUTIFUL, BUT PASSIVE, PRINCESSES. THE WOMEN FEATURED IN "HEY SKY, I'M ON MY WAY" ARE QUITE DIFFERENT. THEY ARE THE COURAGEOUS ADVENTURERS, SCIENTISTS, ARTISTS, HUMAN RIGHTS ACTIVISTS, ATHLETES, PIONEERS IN MEDICINE, AND SOME OF THE WORLD'S GREATESTS EXPLORERS AND RISK TAKERS. THEY DID NOT WAIT FOR MEN TO RESCUE THEM, THEY ARE STRONG, DYNAMIC, AND RESOURCEFUL, AND THEY HAVE QUALITIES THAT ALL WOMEN SHARE. WE IDENTIFY WITH THEM, PERHAPS EVEN WANT TO BE THEM, AND THEY ENRICH OUR LIVES. WE ARE MORE COURAGEOUS BECAUSE OF THEM. THEY HELP US RE-IMAGINE OUR LIVES.

OF COURSE, THERE ARE MANY MORE WOMEN WHO HAVE THE SAME QUALITIES AS THE WOMEN I HAVE CHOSEN FOR THIS BOOK. IT WOULD TAKE VOLUMES TO ILLUSTRATE AND SHARE THEIR STORIES. WHILE YOU LOOK AT THE ILLUSTRATIONS AND READ THE STORIES OF THE COURAGEOUS AND TRAILBLAZING WOMEN PROFILED IN "HEY SKY, I'M ON MY WAY", LIKE AMELIA EARHART, FRIDA KAHLO, ROSA PARKS, MALALA YOUSAFZAI, ANGELA DAVIS AND VALENTINA TERESHKOVA, I ASK YOU THE READER, WHO ARE THE WOMEN ON YOUR LIST? WHAT QUALITIES DO THE WOMEN HAVE WITH WHOM YOU IDENTIFY? WHO ARE THE WOMEN WHO HAVE INSPIRED YOU IN LIFE?

WITH GREAT ENTHUSIASM THIS BOOK IS DEDICATED TO ALL THE WOMEN AND MEN WHO BELIEVE IN GENDER EQUALITY AND WHO ARE WILLING TO CHALLENGE THE STATUS QUO — ESPECIALLY ALL THE YOUNG WOMEN WHO ARE STEPPING UP AND TAKING A LEADERSHIP ROLE AT A TIME WHEN WOMEN'S RIGHTS ARE IN JEOPARDY. THEY WILL BECOME THE NEXT GENERATION OF INFLUENTIAL WOMEN WHO ARE SPEAKING OUT AND SHOUTING, HEY SKY, I'M ON MY WAY!

WHAT MEANS THE "FOREMOST OF THE NOBLE LADIES"

HATSHEPSUT

C.1507 B.C., TEBAS, EGYPT — 1458 B.C., TEBAS, EGYPT

REIGN: 1479-1458 B.C.

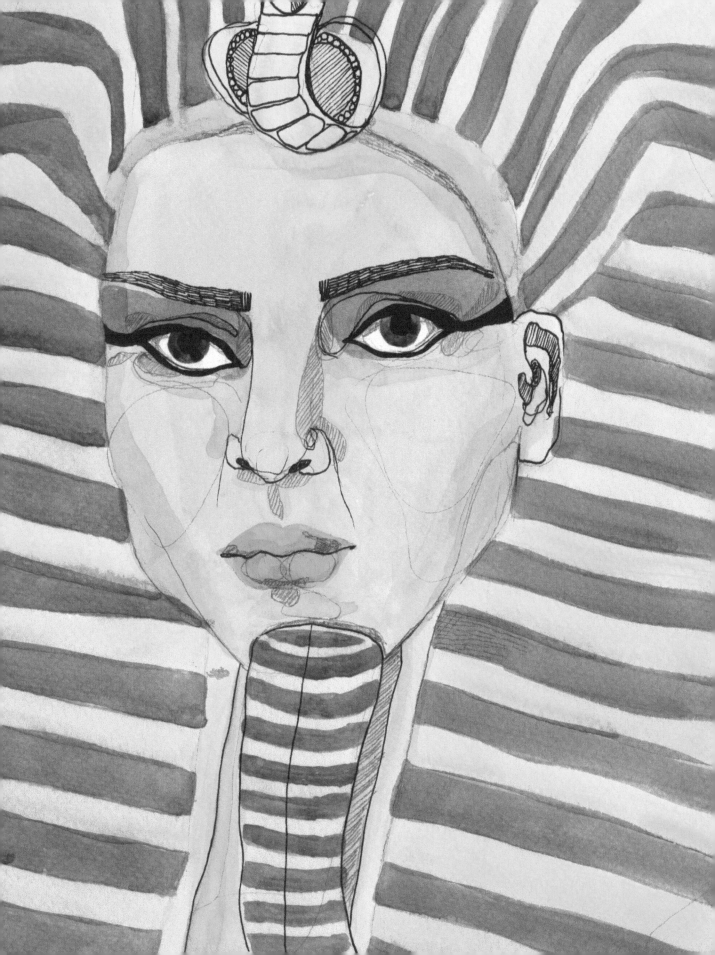

HATSHEPSUT, THE FIFTH PHARAOH OF THE EIGHTEENTH DYNASTY OF EGYPT, RULED THE EMPIRE FOR 22 YEARS. SHE WAS THE SECOND FEMALE PHARAOH IN HISTORY. SHE WAS DAUGHTER AND WIFE OF PHARAOHS, THUTMOSE I AND THUTMOSE II.

THUTMOSE II AND HATSHEPSUT HAD NO SONS WHEN THE PHARAOH PASSED AWAY, SO IT WAS DECIDED THE SUCCESSOR OF THE DYNASTY WOULD BE THUTMOSE III, THE CHILD OF ONE OF PHARAOH'S CONCUBINES. HOWEVER, THUTMOSE III WAS STILL TOO YOUNG, AND SO HATSHEPSUT ASSUMED THE CO-REGENCY UNTIL THUTMOSE III WAS OLD ENOUGH TO GOVERN.

HATSHEPSUT WAS AN AMBITIOUS WOMAN. THE OFFICE OF "KING'S GREAT WIFE" WASN'T ENOUGH FOR HER. WHEN SHE FELT STRONG AND SECURE IN THE THRONE SHE PROCLAIMED HERSELF PHARAOH, "THE GOOD GODDESS MAATKARE".

THE ONLY WAY MOST EGYPTIAN CITIZENS COULD SEE THE PHARAOH WAS THROUGH STATUES AND IMAGERY.

HATSHEPSUT'S IMAGERY CHANGED HER FEMALE APPEARANCE AND RESEMBLED A TRADITIONAL MALE PHARAOH. SHE WORE THE KHAT, THE NEMES HEADDRESS, THE SHENDYT KILT, AND EVEN A BEARD.

SHE PRESENTED HERSELF AS A MALE FIGURE TO EMPHASIZE SHE WAS AS GOOD AS A MAN.

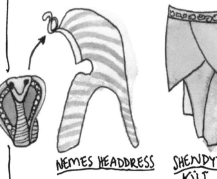

NEMES HEADDRESS SHENDYT KILT BEARD

HATSHEPSUT CONTINUED RULING EVEN WHEN THUTMOSE III WAS OF LEGAL AGE. HOW SHE MANAGED TO DO IT IS STILL A MYSTERY, BUT IN 1458 B.C. SHE DISAPPEARED AND THUTMOSE III SAT ON THE THRONE.

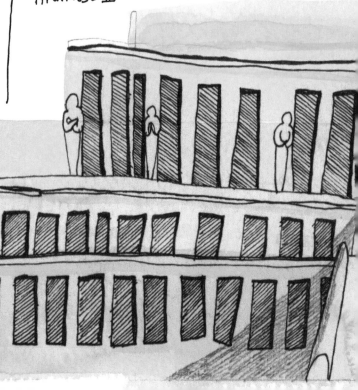

HATSHEPSUT VANISHED OFF THE FACE OF THE EARTH AND THERE IS NO MENTION OF HER DISAPPEARANCE. SOME BELIEVE NATURAL DEATH.

THUTMOSE III ORDERED TO REMOVE HATSHEPSUT FROM THE HISTORICAL RECORDS DURING HIS REIGN. THE STATUES FROM HER TEMPLE WERE DESTROYED. SOME OF THEM WERE BEHEADED AND OTHERS LITERALLY REDUCED TO DUST.

THUTMOSE III THOUGHT HE COULD WIPE OUT HATSHEPSUT'S LEGACY BY ELIMINATING HER IMAGERY.

IT WAS BELIEVED THIS WAS THUTMOSE III REVENGE, BUT TO MANY IT LOOKED MORE LIKE AN ATTEMPT TO REWRITE HISTORY FROM A TRADITIONAL MALE POINT OF VIEW. THIS WOULD LEGITIMIZE HIS LINEAGE AT THE THRONE.

FOLLOWING PHARAOHS DID THE SAME AS THUTMOSE III, EVEN ERASING HATSHEPSUT FROM THE OFFICIAL KING'S LIST.

IN 2005, THE DIRECTOR OF "THE EGYPTIAN MUMMY PROJECT" FOCUSED ON THE MUMMY KV60A, WHICH WAS DISCOVERED MORE THAN A CENTURY AGO. SHE WAS HATSHEPSUT, BUT NOBODY REALIZED THIS AT THE TIME OF ITS DISCOVERY AS THERE WERE NO IDENTIFYING ARTIFACTS BURIED WITH HER BODY.

THE PHARAOH HATSHEPSUT DESTINED TO DARKNESS WOULD SEE THE LIGHT AGAIN.

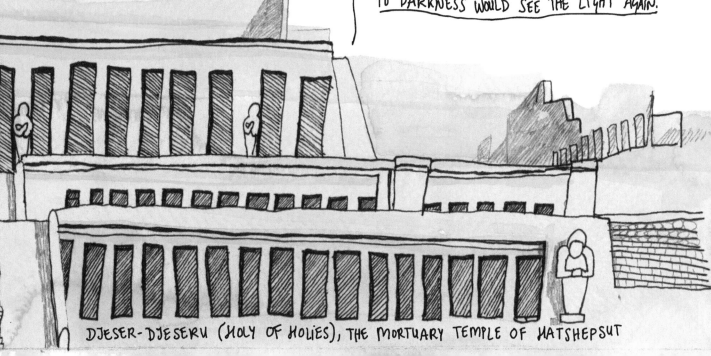

DJESER-DJESERU (HOLY OF HOLIES), THE MORTUARY TEMPLE OF HATSHEPSUT

MURASAKI SHIKIBU

THIS WAS A DESCRIPTIVE NAME ; HER REAL NAME IS UNKNOWN

973 OR 978, KYOTO, JAPAN — 1014 OR 1031, KYOTO, JAPAN

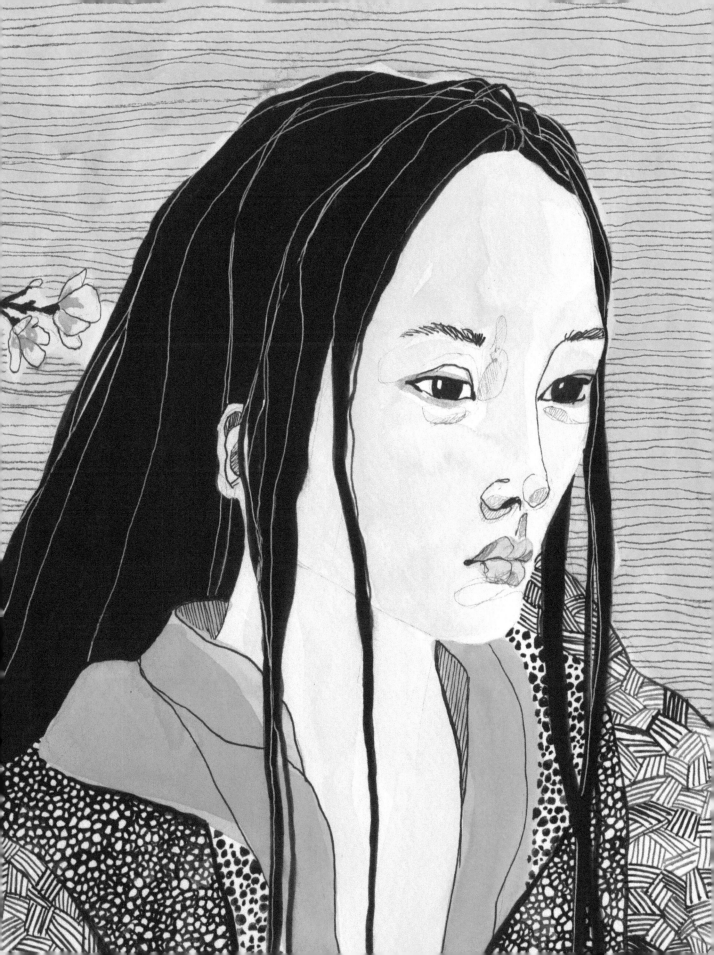

THE _HEIAN PERIOD_ IS THE LAST DIVISION OF CLASSICAL JAPANESE
HISTORY. THIS TIME PERIOD IS GREATLY ADMIRED BY JAPANESE PEOPLE.

WHICH MEANS
"PEACE AND RELIEF"
IN JAPANESE

DURING THIS TIME CONFUCIANISM WAS
AT ITS PEAK. ART AND LITERATURE STOOD OUT
AND THE FIRST SAMURAIS APPEARED IN JAPANESE CULTURE.

IT WAS IN THIS CONTEXT WHEN
THE WORLD'S FIRST _NOVEL_ WAS PRODUCED,
WRITTEN TEXT FROM THE EARLIEST ILLUSTRATED
HANDSCROLL. THE NOVEL WAS ENTITLED
"GENJI MONOGATARI", WRITTEN BY MURASAKI SHIKIBU.

SHIKIBU BELONGED THE FUJIWARA CLAN, ONE OF THE
MOST DISTINGUISHED AND POWERFUL FAMILIES OF REGENTS IN JAPAN.
HER GREAT-GRANDFATHER, FUJIWARA-NO-KANESUKE, WAS
A CELEBRATED POET, AND HER FATHER WAS A MAN OF LETTERS.
IN 996, MURASAKI'S FATHER WOULD BE NAMED GOVERNOR OF
ECHIZEN PROVINCE. SHIKIBU MET HER HUSBAND IN ECHIZEN,
A MUCH OLDER DISTANT COUSIN.
THREE YEARS LATER SHIKIBU WAS WIDOWED WITH TWO
DAUGHTERS AND RETIRED TO PRIVATE LIFE.
IT IS AT THIS POINT WHEN SHE WROTE THE _MASTERPIECE._

SHIKIBU BECAME A LADY-IN-WAITING
AT _ICHIJO'S IMPERIAL COURT._

EARLY IN THE 11TH CENTURY LITERARY PRODUCTION
CAME FROM ARISTOCRACY. WOMEN HAD A MORE PRIVILEGED POSITION
IN SOCIETY THAN THEY WOULD HAVE LATER IN FUTURE CENTURIES.
FOR EXAMPLE, WOMEN RECEIVED THE SAME EDUCATION AS MEN.

IN THIS TIME PERIOD MEN WERE MORE DEDICATED TO CHINESE STUDIES
(WOMEN WERE EXCLUDED) SO, AROUND YEAR 1000,
JAPANESE LITERATURE WAS IN <u>WOMEN'S HANDS</u>.

GENJI MONOGATARI (THE TALE OF GENJI)

PRODUCED IN THE EARLY YEARS OF THE 11TH CENTURY.
THE NOVEL RELATES PRINCE GENJI'S ROMANTIC LIFE,
A CHARACTER CREATED BY THE AUTHOR,
AND HIS DESCENDANTS.

SHIKIBU SHARED A PSYCHOLOGICAL DESCRIPTION OF
THE LIFE AT THE COURT AND ITS WEAKNESSES,
MERITS, AND DEFECTS.

UNTIL THEN TALES HAD BEEN SHORT STORIES
INSPIRED BY FANTASY. "GENJI MONOGATARI"
PORTRAYED EXPERIENCES IN
UPPER-CLASS SOCIETY AND HUMAN
FEELINGS AND EMOTION.
IT WAS INNOVATIVE FOR THE TIME.

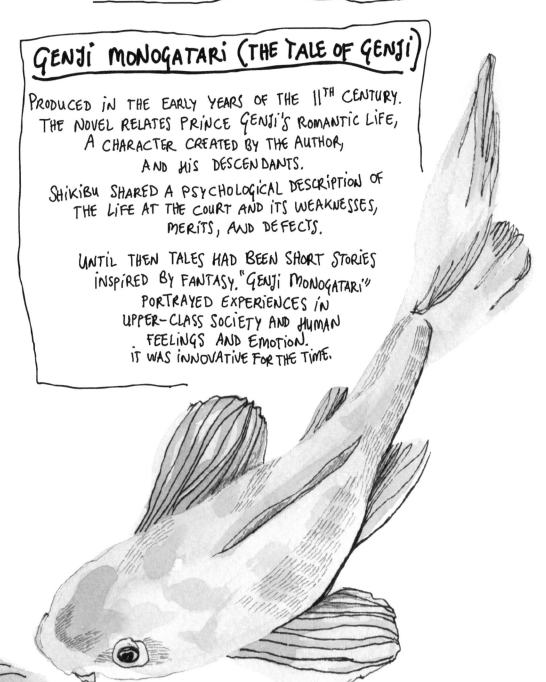

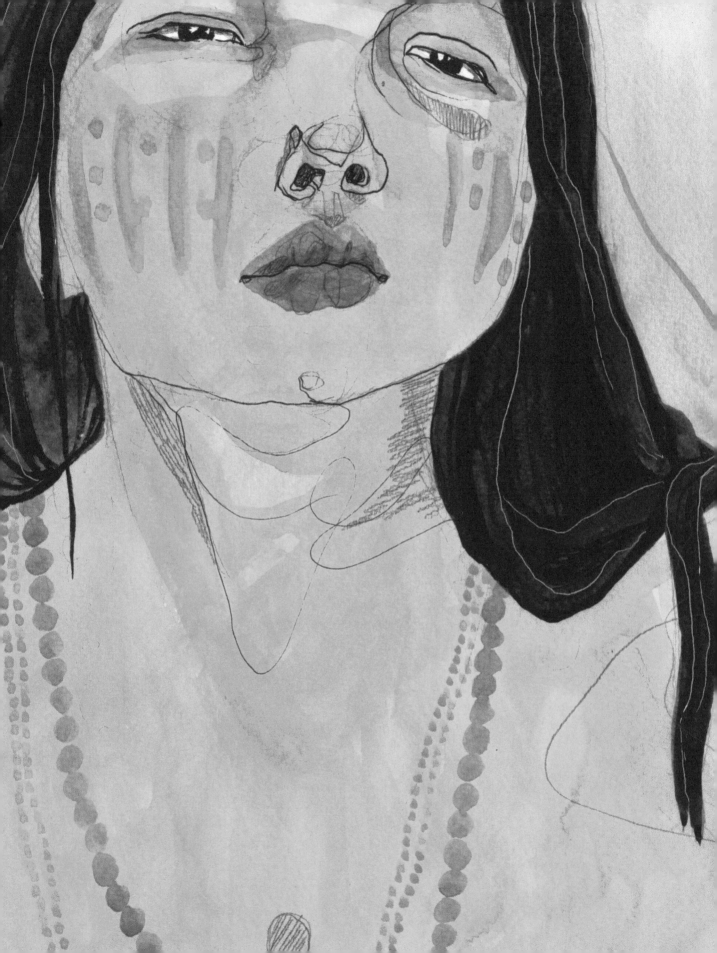

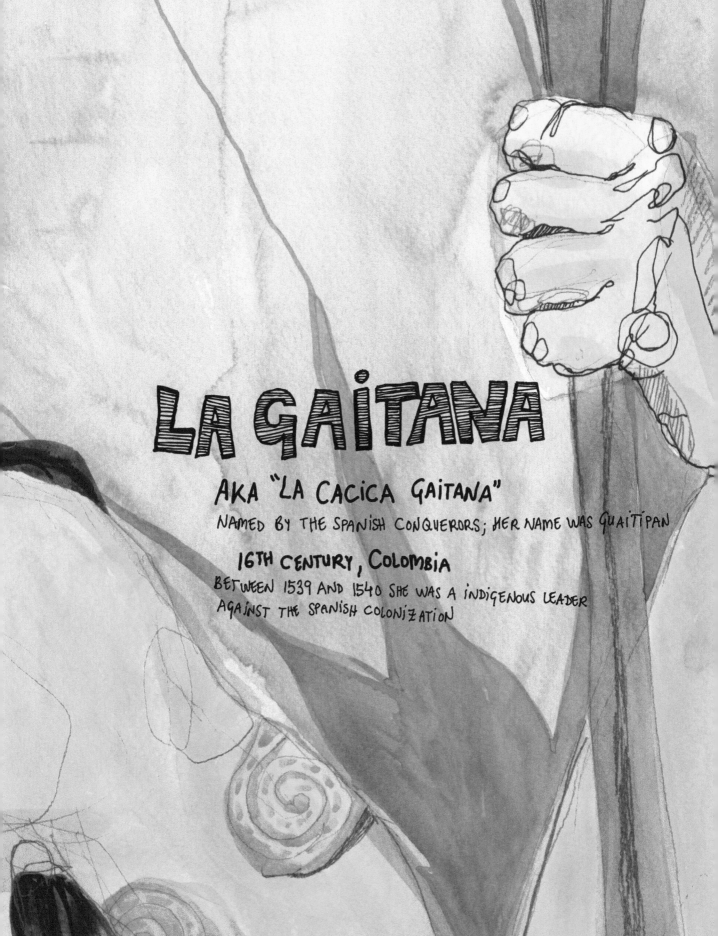

LA GAITANA

AKA "LA CACICA GAITANA"
NAMED BY THE SPANISH CONQUERORS; HER NAME WAS GUAITIPAN

16TH CENTURY, COLOMBIA
BETWEEN 1539 AND 1540 SHE WAS A INDIGENOUS LEADER
AGAINST THE SPANISH COLONIZATION

MODERN DAY COLOMBIA IS A UNITARY REPUBLIC FORMED BY THIRTY-TWO DEPARTMENTS.
DURING THE 16TH CENTURY, IN WHAT IS NOW KNOWN AS THE HUILA DEPARTMENT, LIVED SEVERAL INDIGENOUS TRIBES: THE YALCÓN, THE AVIRAMA, THE PIÑAO, THE GUANACA, THE PAEZ, THE ANDAQUI, THE TIMANÁ, AND THE PIJAO.

IN 1535 SEBASTIÁN DE BELALCÁZAR, A SPANISH CONQUEROR, FOUNDED QUITO.

SPANIARDS ARRIVED AT THE AMERICAN CONTINENT IN SEARCH FOR TREASURE AND GOLD.

BELALCÁZAR LEARNED NATIVE TRIBES WERE RICH IN GOLD IN THE NORTH.
HE SENT PEDRO AÑASCO TO CREATE A TRADE ROUTE THROUGH THE MAGDALENA VALLEY.
AÑASCO WAS KNOWN FOR HIS CRUELTY TOWARD THE INDIGENOUS PEOPLE.

AÑASCO SOON FOUNDED TIMANÁ AND CALLED ON THE INDIGENOUS LEADERS TO PAY HIM TRIBUTE AND VASSALAGE.

A YOUNG LEADER, LA GAITANA'S SON, WAS RELUCTANT AND REFUSED TO SUBMIT TO AÑASCO'S ARROGANT DEMANDS. AÑASCO THE CONQUEROR PUNISHED THE YOUNG LEADER AND COMMANDED THAT HE BE BURNT ALIVE IN FRONT OF LA GAITANA.
LA GAITANA WAS FORCED TO WATCH HER SON'S TORTURE.
SHE WOULD SOON SEEK REVENGE FOR THE MURDER.

LA GAITANA SENT MESSAGES TO ALL THE INDIGENOUS TRIBES TO DECLARE WAR AND ARMED RESISTANCE AGAINST THE COLONIZATION BY THE SPANISH.

MANY INDIGENOUS PEOPLE BELIEVED SPANIARDS ON HORSES WERE SENT BY THE GODS. LA GAITANA MADE HER PEOPLE REALIZE THE SPANIARDS WERE JUST HUMAN BEINGS NOT GODS, AND THE HORSES WERE JUST ANIMALS LIKE THE PUMA. A UNION OF TRIBES WOULD FIGHT AGAINST THE SPANIARDS.

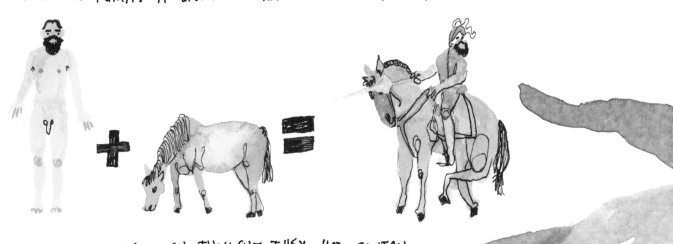

AÑASCO AND HIS MEN THOUGHT THEY HAD CONTROL OF THE INDIGENOUS PEOPLE. BUT A TROOP OF OVER 6,000 INDIGENOUS WARRIORS ATTACKED AÑASCO'S SMALL SPANISH FORT. IT WAS A MASSACRE.

AÑASCO WAS CAPTURED ALIVE AND BROUGHT TO LA GAITANA. SHE WANTED HIM TO SUFFER. LA GAITANA GOT HER REVENGE BY TORTURING AÑASCO AND STAKING HIM TO THE GROUND IN MIDDLE OF THE VILLAGE.

THE BATTLES BETWEEN THE SPANIARDS AND NATIVES CONTINUED. MORE SPANISH REINFORCEMENTS ARRIVED UNTIL AROUND 600 INDIGENOUS PEOPLE REMAINED OUT OF 14,000 OR 15,000.

23

MARY READ

1684, LONDON, ENGLAND — 1721, PORT ROYAL, JAMAICA

THERE ARE DOUBTS ABOUT THE EXACT DATE
OF HER BIRTH, BETWEEN 1684 AND 1691

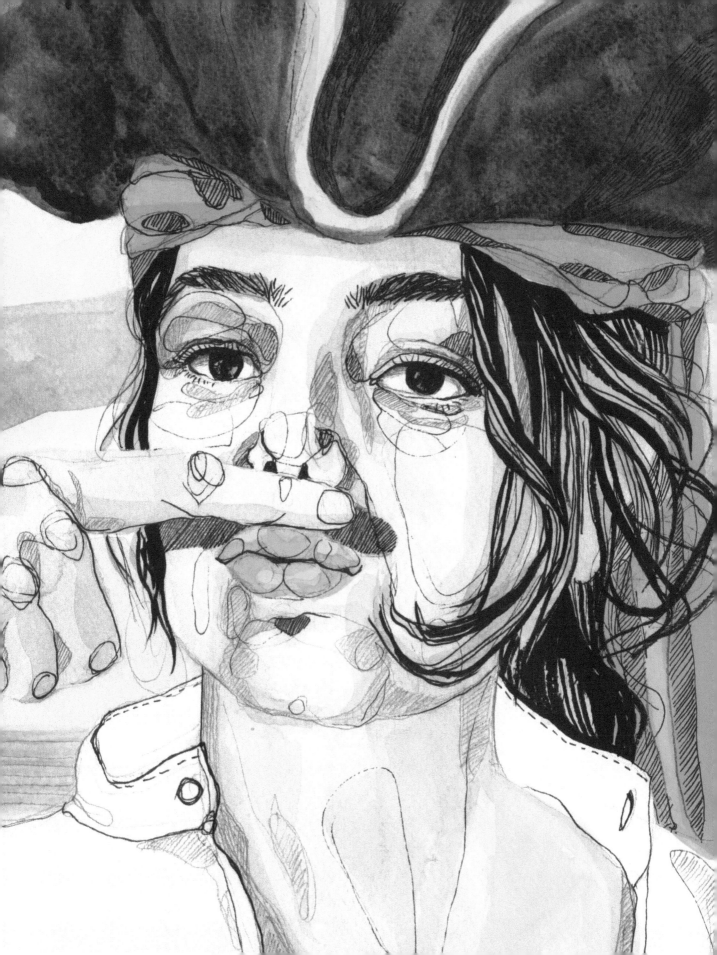

MARY READ, ALSO KNOWN AS MARK READ, WAS AN ENGLISH PIRATE BORN IN ENGLAND TO THE WIDOW OF A SEA CAPTAIN, MARY WAS AN ILLEGITIMATE CHILD FOLLOWING AN AFFAIR HER MOTHER HAD AFTER THE DISAPPEARANCE OF HER HUSBAND.
MARY'S MOTHER ATTEMPTED TO HIDE THE BIRTH OF MARY TO CONTINUE RECEIVING MARY'S PATERNAL GRANDMOTHER'S INHERITANCE.
THE GRANDMOTHER WAS APPARENTLY FOOLED.
FROM THAT MOMENT ON, DINGUISED HER AS HER OLDER AN DECEASED LEGITIMATE BROTHER MARK, MARY'S NAME CHANGED TO MARK READ AND SHE WAS RAISED BY HER MOTHER AS A BOY.

MARY WAS HAPPY WITH HER LIFE AS A BOY. SHE DRESSED AS A YOUNG MAN AND HAD BOYISH HABITS. WHEN SHE GREW UP SHE ENROLLED AS A SAILOR AND FOUND EMPLOYMET ON A SHIP.

DURING MARY'S EMPLOYMENT SHE FELL IN LOVE WITH A SOLDIER WHO KNEW HER REAL GENDER. THEY MARRIED. AND LATER, OPENED AN INN NAMED "DE DRIE HOEFIJZERS" IN THE NETHERLANDS, NEAR BREDA CASTLE.
→ THE THREE HORSESHOES

DURING THIS TIME, SHE DRESSED AS A FEMALE FOR THE FIRST TIME AND HAD A TRADITIONAL WOMAN'S LIFE AS A WIFE. BUT THIS SITUATION DIDN'T LAST FOR TOO LONG. HER HUSBAND DIED DUE TO A FEVER AND THE BUSINESS WASN'T GOING WELL, SO MARY TOOK HER MALE DRESS CLOTHES AND REENLISTED TO THE ARMY.
THE BOAT WHERE SHE WAS TRAVELLING GOT CAPTURED BY THE FAMOUS CALICO JACK. THE PIRATES THOUGHT SHE WAS A MAN.

A PIRATE WHO LOVED THE COLOURING CALICO CLOTHES, WHERE HIS NICKNAME WAS TAKEN FROM.

WHILE IMPRISONED, MARY MET [ANNE BONNY], THE ONLY WOMAN ON THE SHIP AND THE WIFE OF JOHN RACKHAM (CALICO JACK). BONNY TRIED TO KEEP MARY'S SECRET BUT FINALLY HAD TO CONFESS THAT MARY WAS A WOMAN.

MARY BECAME A PIRATE AND TOOK PART IN NUMEROUS ATTACKS IN THE CARIBBEAN SEA. SHE EVEN GOT MARRIED TO A MEMBER OF THE PIRATE CREW.
IN 1720 "THE REVENGE" PIRATE SHIP WAS CAPTURED BY BRITISH TROOPS IN JAMAICA.

MARY READ AND ANNE BONNY DODGED THE GALLOWS BY STATING THEY WERE BOTH PREGNANT.

BONNY DISAPPEARED AND NOBODY KNEW ANYTHING ELSE ABOUT HER. THERE ARE MANY THEORIES ABOUT HER END: HER FATHER, AN IMPORTANT LAWYER, HELPED HER TO SCAPE AND SHE WENT BACK TO CAROLINA WITH A NEW IDENTITY, OR MAYBE SHE WENT BACK WITH HER HUSBAND, OR MAYBE SHE BECAME A NUN.

MARY READ WASN'T THAT LUCKY, AND SHE DIED OF A FEVER WHEN SHE WAS IN PRISON. SHE WAS JUST 37 YEARS OLD.
MARY READ AND ANNE BONNY ARE THE ONLY TWO KNOWN WOMEN DECLARED GUILTY OF PIRACY IN THE GOLDEN AGE OF PIRACY.
MARY READ'S LIFE HAS BEEN DEPICTED MANY TIMES IN BOTH LITERATURE AND IN CINEMA.

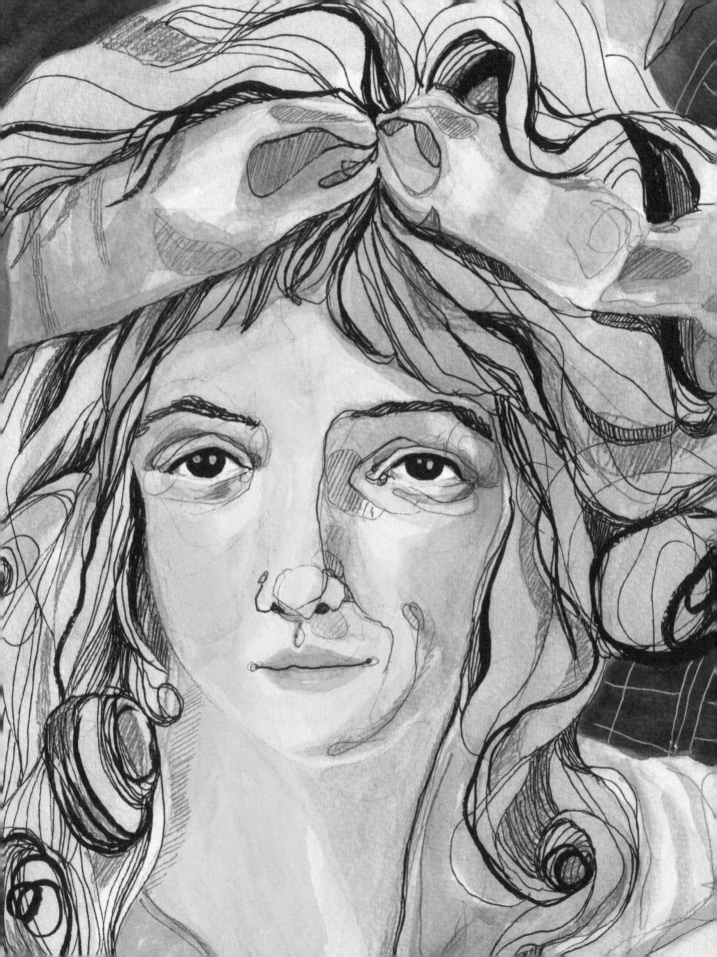

THÉROIGNE DE MÉRICOURT

13TH AUGUST 1762, MARCOURT, PRINCE-BISHOPRIC OF LIÈGE —
(NOW BELGIUM)
9TH JUNE 1817, PARIS, FRANCE

ANNE JOSÈPHE TERWAGNE WAS WELL-KNOWN DURING THE FRENCH REVOLUTION.
BORN IN MANCOURT, TERWAGNE LEFT HER FAMILY BEHIND AND TRAVELED TO ENGLAND
LOOKING FOR ADVENTURE. YEARS LATER, SHE MOVED TO PARIS WHERE SHE
CHANGED HER NAME TO THÉROIGNE DE MÉRICOURT.

FRENCH REVOLUTION 1789-1799

FRANCE WAS FERTILE BREEDING GROUND FOR REVOLUTION.
THE FRENCH REVOLUTION MEANT THE END TO THE ANCIENT RÉGIME,
ABOLITION OF MONARCHY, AND FEUDALISM.

DURING THE STORMING OF THE BASTILLE,
THE COURAGE OF THE PEOPLE INSPIRED THÉROIGNE.
THEY CHANTED:

"LIBERTY, EQUALITY, FRATERNITY, OR DEATH"

THE MARCH TO VERSAILLES.
OCTOBER 1789

THIS UPRISING WAS SUPPORTED BY A GROUP
OF WOMEN WHO PROTESTED THE SHORTAGE OF
BREAD AND THE HIGH PRICE OF FOOD AND SERVICES.
KING LOUIS XVI AND HIS WIFE, MARIE-ANTOINETTE,
WERE FORCED TO GO BACK TO PARIS.

IT IS BELIEVED THÉROIGNE DE MÉRICOURT LEAD THE CROWD, SHE WAS A BEAUTIFUL,
TALL, AND YOUNG WOMAN DRESSED IN RED HOLDING A SWORD.

IN 1790, THÉROIGNE DE MÉRICOURT WENT BACK HOME. ONCE IN LIÈGE SHE WAS ARRESTED
AND ACCUSED OF BEING SENT BY THE JACOBINS TO KILL QUEEN MARIE-ANTOINETTE.
SHE WAS LATER RELEASED DUE TO LACK OF EVIDENCE.
↳ THE JACOBINS WERE THE RADICAL WING
IN THE REVOLUTION (ROBESPIERRE WAS THE LEADER)
IN OPPOSITION TO GIRONDINS, THE MODERATE PARTY
BELONGING TO THE HIGH BOURGEOISIE.

WHEN THÉROIGNE ARRIVED BACK TO PARIS SHE WAS HONORED BY THE JACOBINS AS A HEROINE. SHE TRIED TO FORM A BATTALION OF WOMEN AND TRAINED THEM TO USE ARMS. *"Let us arm ourselves. Let us show the men that we are not their inferior in courage or virtue. Let us rise to the level of our destinies and break our chains"*

THIS CALL TO ARMS WAS NOT WELCOMED BY CONSERVATIVE REVOLUTIONARIES. DUE TO THE WAY SHE DRESSED AND HER PASSIONATE SPEECHES THÉROIGNE WAS CALLED "THE AMAZON OF LIBERTY". LIKE OTHER FAMOUS FEMINISTS IN THE MOVEMENT, LIKE OLYMPE DE GEUGES AND MADAME ROLAND, THÉROIGNE FOUGHT FERVENTLY FOR WOMEN RIGHTS. IN 1793 THE JACOBINS DISMISSED REVOLUTIONARY WOMEN AS DANGEROUS RABBLE-ROUSERS. THE WOMEN'S MOVEMENT WAS ABOLISHED AND THEIR LEADERS WERE ARRESTED.

THAT SAME YEAR, IN MAY OF 1793, THÉROIGNE WAS ASSAULTED BY A GROUP OF JACOBINS WOMEN WHEN SHE WAS WALKING BY THE TUILLERIES GARDEN. THÉROIGNE WOULD NO LONGER BE THE SAME. SHE SUFFERED FROM PERSECUTION COMPLEX.

THÉROIGNE SPENT THE NEXT 23 YEARS IN AN ASYLUM. IN PROTEST SHE REFUSED TO GET DRESSED, FLOODED THE FLOOR OF THE CELL AND WALKED BAREFOOT ON THE WATER. WHILE RECITING SPEECHES ABOUT REVOLUTION AND FREEDOM.

HER STORY SERVED AS INSPIRATION TO BAUDELAIRE IN "LES FLEURS DU MAL". IT IS BELIEVED THE WOMAN WHO APPEARS IN "LIBERTY LEADING THE PEOPLE" OF DELACROIX IS THÉROIGNE.

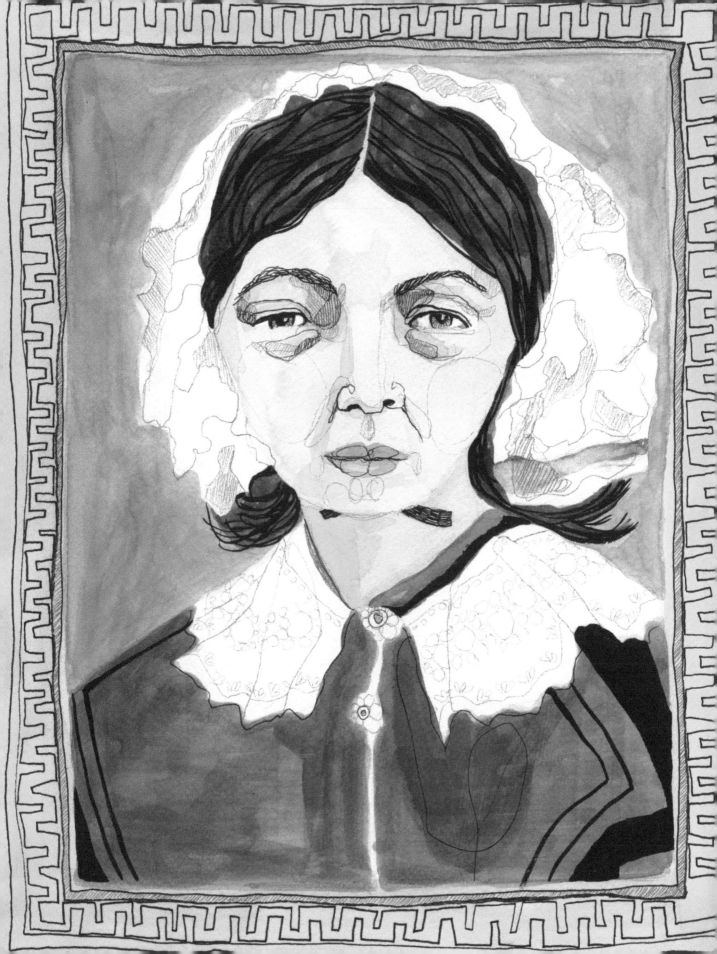

FLORENCE NIGHTINGALE

HER NAME IS COMING FROM THE CITY WHERE SHE WAS BORN IN

"THE LADY WITH THE LAMP"

12TH MAY 1820, FLORENCE, TUSCANY — 13TH AUGUST 1910, LONDON, ENGLAND

THE PRECURSOR OF MODERN NURSING

FLORENCE NIGHTINGALE GREW UP IN AN UPPER CLASS-FAMILY IN THE ENGLISH COUNTRYSIDE. HER FATHER GAVE HER AND HER SISTER A HIGH EDUCATION. AT THE AGE OF 17 SHE FELT THE CALL OF GOD TO DO SOMETHING GOOD.
IN 1844 SHE DECIDED SHE WOULD BECOME A NURSE.
HER FAMILY HOWEVER, BELIEVED NURSING WAS LOW CLASS WORK.

33

IN 1853, THE CRIMEAN WAR BROKE OUT. THE CRIMEAN WAR IS CONSIDERED TO BE THE FIRST MODERN WAR IN HISTORY.

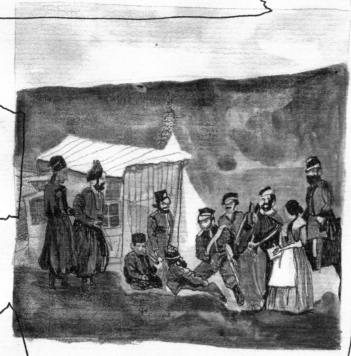

DRAWING OF A PHOTO TAKEN BY ROGER FENTON.

SIDNEY HERBERT, SECRETARY OF WAR, ASKED NIGHTINGALE TO RECRUIT 38 NURSES TO BRING THEM TO A MILITARY HOSPITAL IN SCUTARI, TURKEY.

IT WAS THE FIRST TIME WOMEN WERE OFFICIALLY SERVING AT THE ARMY.

HOSPITALS BY THAT TIME HAD TERRIBLE CONDITIONS. THE FIRST THING FLORENCE DID WAS MAKE SURE THAT HOSPITALS WERE CLEAN AND PATIENTS WERE PROPERLY FED.

A PICTURE OF FLORENCE WITH A LAMP LOOKING AFTER HER PATIENTS APPEARED IN THE NEWSPAPERS. NEWS COVERAGE MADE NIGHTINGALE REMARKABLY POPULAR. SHE RECEIVED LETTERS OF SUPPORT AND HER PICTURE WAS EVEN PRINTED ON SOUVENIRS.

NIGHTINGALE DIDN'T LIKE HER POPULARITY. WHEN SHE RETURNED FROM WAR SHE USED A PSEUDONYM, MS. SMITH.

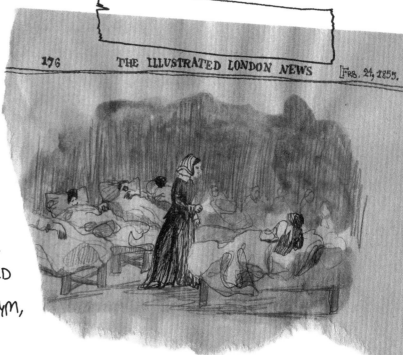

176 THE ILLUSTRATED LONDON NEWS FEB. 24, 1855.

AFTER SEVERAL YEARS NIGHTINGALE MADE HER FAME USEFUL. SHE CONVINCED QUEEN VICTORIA TO INVEST IN STUDIES ABOUT CARING FOR THE WOUNDED IN WAR. SHE DEVELOPED A COMMITTEE TO ANALYZE THE DATA SHE COLLECTED IN CRIMEAN WAR. FOR EXAMPLE:

CRIMEAN WAR.............................. 20,000 BRITISH SOLDIERS DEAD

• 3,000 DEAD IN BATTLE.

• 17,000 DEAD IN HOSPITALS DUE TO ILLNESSES INFECTED BECAUSE OF THE LACK OF HYGIENE.

DRAWING OF A PHOTO TAKEN BY ROGER FENTON.

IN 1859 NIGHTINGALE PUBLISHED TWO BOOKS: "NOTES ON NURSING" AND "NOTES ON HOSPITALS."
FOLLOWING THESE PUBLICATIONS SHE DEVELOPED THE FIRST OFFICIAL NURSES' TRAINING PROGRAM, "THE NIGHTINGALE SCHOOL FOR NURSES".
IN 1912, THE INTERNATIONAL COMMITTEE OF RED CROSS CREATED THE FLORENCE NIGHTINGALE MEDAL, WHICH IS THE HIGHEST INTERNATIONAL DISTINCTION A NURSE CAN RECEIVE.
INTERNATIONAL NURSES DAY IS ON THE 12TH OF MAY, FLORENCE'S BIRTHDAY.

FLORENCE NIGHTINGALE'S EFFORT IMPROVED THE QUALITY OF HOSPITALS AND THE MILITARY MEDICINE, HELPING TO REFORM THE PUBLIC HEALTH SYSTEM AND RECOGNIZING NURSING AS A RESPECTABLE CAREER.

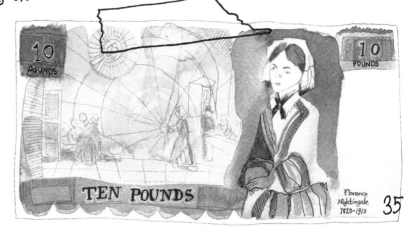

TEN POUNDS

Florence Nightingale 1820-1910

35

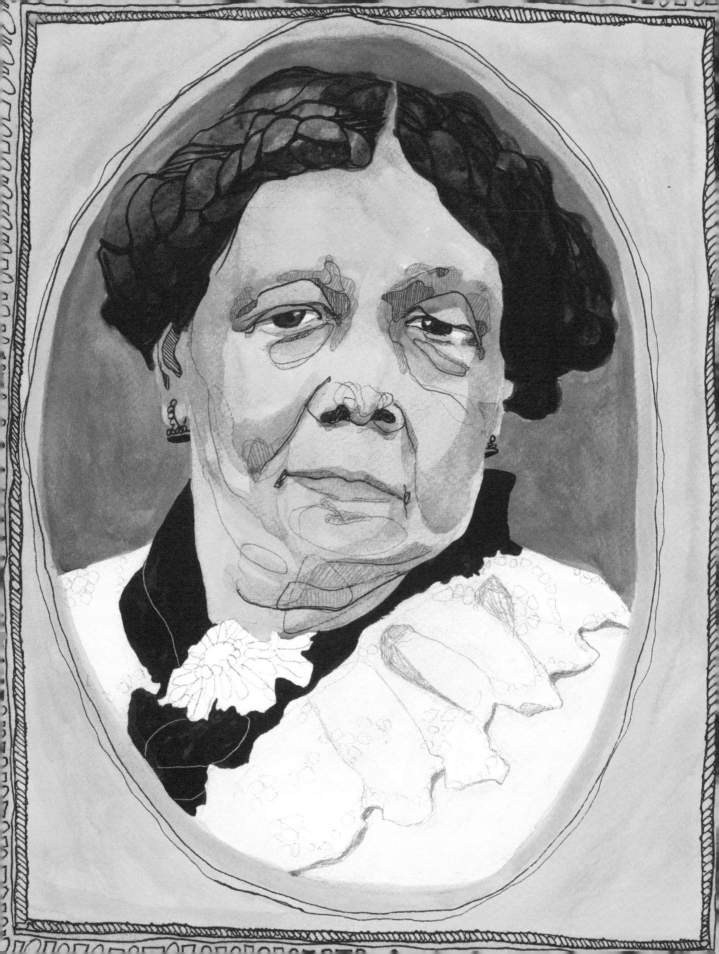

MARY SEACOLE

1805, KINGSTON, JAMAICA — 14TH MAY 1881, LONDON, ENGLAND

Mother Seacole

After Crimean War the figure of Nightingale was viewed as the heroine of the British Army, but many soldiers also remembered another woman, Mother Seacole.

Seacole was relatively UNKNOWN until 1973, when a British nurse found a copy of her autobiography in a bookshop, "Wonderful Adventures of Mrs. Seacole in Many Lands."

Mother Seacole was born in Jamaica. She was the daughter of a Scottish lieutenant, and a free Jamaican woman. Her mum managed a hostel and practiced traditional Caribbean medicine. She passed her knowledge down to Mary.

When Seacole's mother died Mary assumed the management of her inn. In 1850 a cholera epidemic swept across Jamaica claiming 31,000 lives. Mary worked hand in hand with doctors to care for the sick.

After several years Seacole travelled to Panama to visit her brother. She opened a second hostel.

When cholera arrived in Panama she offered help to medical authorities. They first refused because she was a black woman but finally accepted her help.

Mary insisted good hygiene and eating well to fight the epidemic.

In 1853, when CRIMEAN WAR started. Seacole heard Nightingale was looking for nurses. Seacole was convinced her knowledge about tropical diseases would be useful, she travelled to London.

ONCE IN LONDON SEACOLE WENT TO THE WAR OFFICE TO JOIN A CONTINGENT OF NURSES. BUT THEY TURNED HER DOWN. SHE FUNDED HER OWN TRIP TO CRIMEA.

CRIMEA

IN CRIMEA SEACOLE MET NIGHTINGALE. BUT MARY DIDN'T MEET THE REQUIREMENTS FOR BEING A NURSE. SHE WAS BLACK, OVER 50, AND FROM A LOW SOCIAL CLASS.

SEACOLE DID NOT GIVE UP. SHE SAILED TO BALAKLAVA WHERE SHE OPENED "THE BRITISH HOTEL". SHE PROVIDED ROOMS FOR SOLDIERS. THE BASEMENT WAS A PLACE FOR SELLING FOOD, DRINKS, AND CATERING FOR SOLDIERS. SEACOLE TOOK SPECIAL CARE OF SICK PEOPLE. SHE KNEW A GOOD DIET WAS IMPORTANT FOR THEIR RECOVERY. EVERY MORNING SEACOLE WENT TO THE BATTLEFIELD TO ATTEND TO WOUNDED SOLDIERS. GRATEFUL SOLDIERS CALLED HER "MAMA SEACOLE."

IN 1956 THE CRIMEAN WAR ENDED. COUNT GLEICHEN, QUEEN VICTORIA'S NEPHEW, AN OFFICER, SCULPTOR AND FRIEND OF MARY, MADE A BUST OF HER WHERE SHE APPEARS WEARING FOUR MEDALS: THE BRITISH CRIMEA MEDAL, THE FRENCH LÉGION D'HONNEUR, THE TURKISK ORDER OF THE MEDJIDIE MEDAL, AND A FOURTH MEDAL, A SARDINIAN AWARD.

SEACOLE PASSED AWAY IN PADDINGTON, LONDON.

LOÏE
FULLER

15TH JANUARY 1862, FULLERSBURG, ILLINOIS, U.S. –
1ST JANUARY 1928, PARIS, FRANCE

HER REAL NAME WAS MARIE LOUISE FULLER, LOUIE FULLER ON THE AMERICAN STAGE. WHEN SHE MOVED TO PARIS SHE WAS RENAMED LOÏE, WHICH WAS A PUN ON LOUIE AND L'OUIE (THE SENSE OF HEARING IN FRENCH) L'OÏE MEANS "RECEPTIVENESS" IN MEDIEVAL FRENCH. SHE WAS ALSO CALLED "LO LO FULLER".

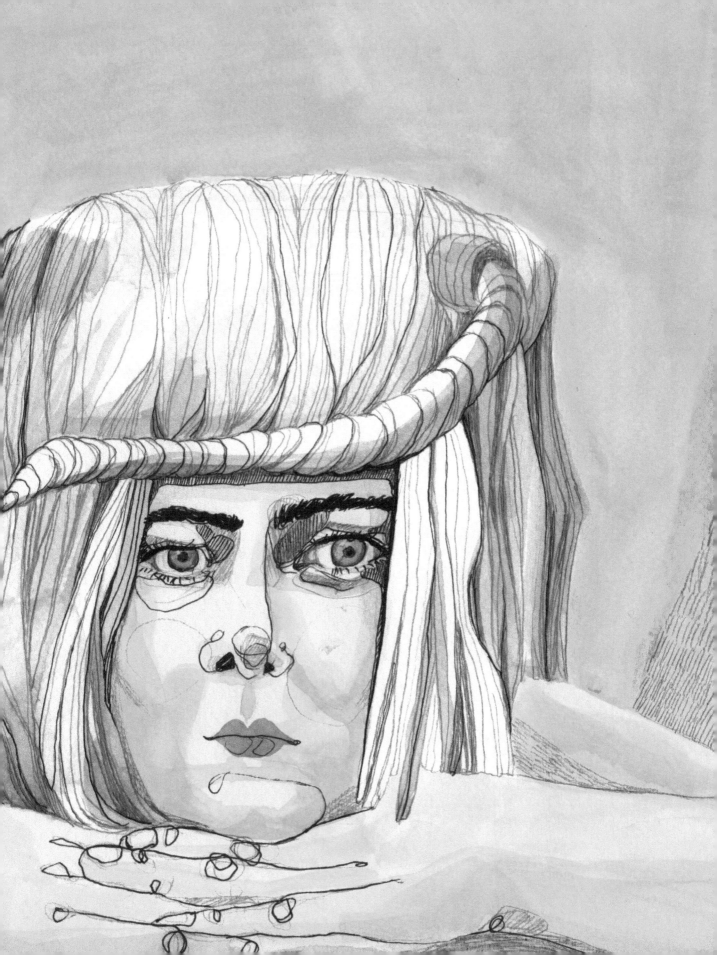

DANCER, ACTRESS, WRITER, INVENTOR, PRODUCER, SCIENTIST, LOÏE FULLER WANTED TO BREAK THE RULES IN DANCE. AND SHE DID JUST THAT.

IT WAS THE END OF THE 19TH CENTURY WHEN FULLER STRIPPED AWAY TRADITIONAL CHOREOGRAPHY.

DURING THIS TIME PERIOD DANCERS HAD TO PROVE THEIR SKILLS AT A TECHNICAL LEVEL. WOMEN DANCERS HAD TO EXHIBIT LEG MOVEMENTS. FULLER TRAINED AS A BURLESQUE SKIRT DANCER. SHE INNOVATED DANCE USING HER INSTINCTS. SHE SAW BEAUTY IN DANCE WHERE OTHERS DID NOT.

FULLER DEDICATED HERSELF TO DANCE. SHE WANTED TO BE SUCCESSFUL. SHE MOVED TO EUROPE WITH THAT CHALLENGE IN MIND.

FULLER'S DEFINED HER STYLE BY THE MOVEMENT OF TWIRLING AND SWIRLING FABRICS AND FLOWING COLORFUL CLOTHES. LIGHT WAS ALSO A CRITICAL ELEMENT IN HER DANCE STYLE. AND THE DRAMATICAL STRENGTH OF HER DANCE WAS THE RESULT OF THE VISUAL EFFECTS SHE PRODUCED. SHE OPENED A DOOR TO ABSTRACTION ON THE STAGE.

FULLER WAS ALSO VERY INTERESTED IN SCIENCE. SHE HELD PATENTS OF HER INVENTIONS AND CHEMICAL COMPOUNDS FOR FABRIC DYING. SHE EVEN HAD HER OWN LAB.
MOST OF HER CHOREOGRAPHED DANCE ROUTINES REPRESENTED THE NATURE MOTIF. FLOWERS, A BUTTERFLY, AND FIRE.
SHE WAS AN INSPIRATION TO THE ART NOUVEU ARTISTS.

FULLER'S MOST FAMOUS PERFORMANCE WAS THE SERPENTINE DANCE, FILMED BY THE PIONEER FILM-MAKERS, THE LUMIÈRE BROTHERS IN 1896.

MANY ARTISTS AND SCIENTISTS LIKE AUGUST RODIN, MARIE CURIE, TOULOUSE-LAUTREC, RESPECTED FULLER'S WORK.

FULLER WASN'T ATHLETIC BY TRADITIONAL STANDARDS OF THE TIME. SHE WAS MORE ROUNDED AND HEAVIER THAN MOST DANCERS, BUT HER WEIGHT DIDN'T INTERFERE WITH HER PERFORMANCES.

FULLER SPONSORED ISADORA DUNCAN, THE WOMAN WHO MADE HISTORY AS THE FIRST REAL MODERN DANCER. OVER THE YEARS, FULLER WENT RELATIVELY UNNOTICED, HIDDEN BEHIND HER FLOWING CLOTHES, UNLIKE HER CONTEMPORARY, ISADORA, WHO EXALTED THE ROLE OF THE BODY ON STAGE DANCING WITH BARE ARMS AND LEGS, BELIEVING NATURALNESS LIES ON FEMALE BODY.

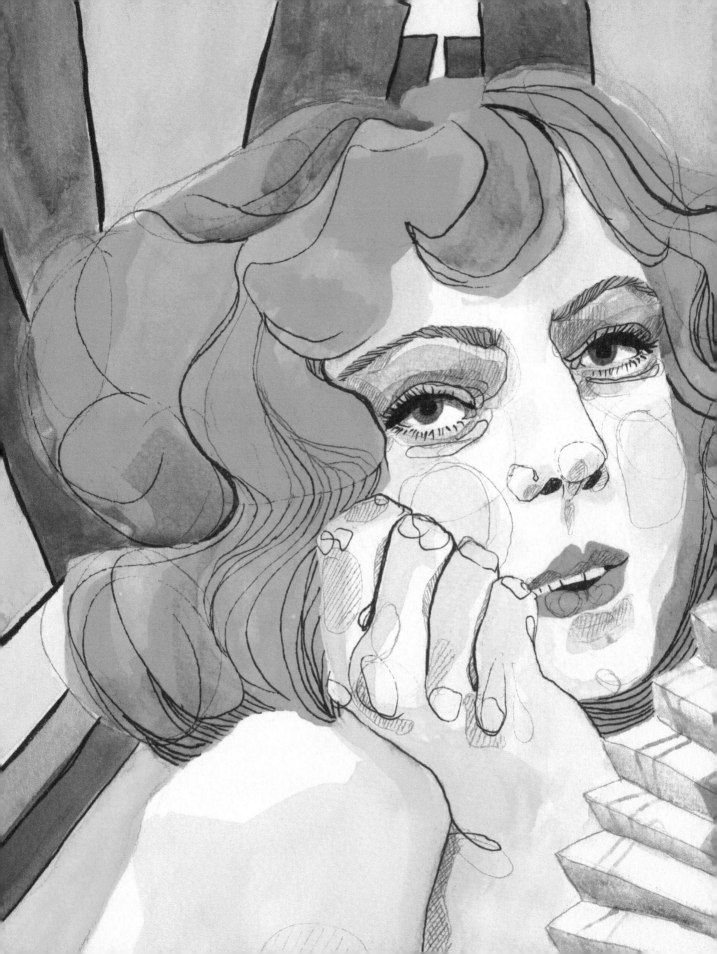

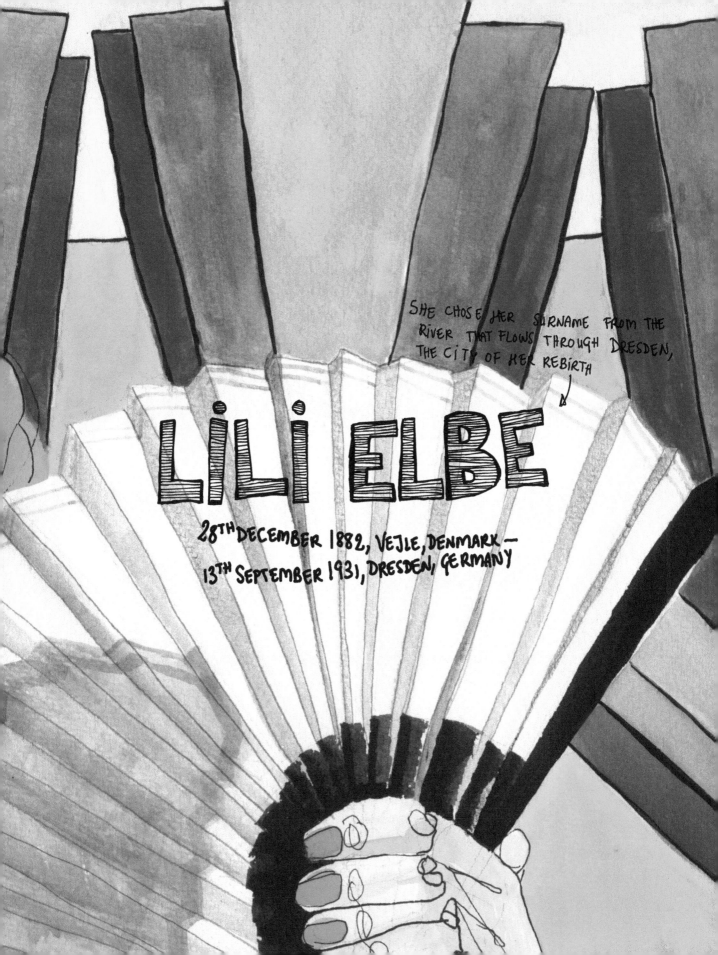

LILI ELBE WAS BORN EINAR MAGNUS ANDREAS WEGENER IN DECEMBER 1882 AS A MAN. SHE WAS A DANISH TRANSGENDER WOMAN KNOWN FOR HAVING ONE OF THE FIRST GENDER REASSIGNMENT OPERATIONS.

LILI ELBE WAS MARRIED TO GERDA GOTTLIEB, AN ART DECO ILLUSTRATOR WELL KNOWN FOR HER PORTRAITS OF FASHIONABLE WOMEN. ONE DAY ONE OF GERDA'S MODEL DIDN'T SHOW UP SO SHE ASKED EINAR TO POSE FOR HER WEARING WOMEN'S CLOTHING. THIS WAS THE FIRST TIME LILI ELBE SHOWED HER TRUE GENDER IDENTITY. LILI WAS A WOMAN TRAPPED IN EINART'S BODY.

ELBE LATER CONFESSED TO GOTTLIEB SHE WAS BORN A MAN. AFTER HER INITIAL SHOCK, GOTTLIEB, ENCOURAGED LILI AND LOVED HER AS A BEST FRIEND. LILI BECAME HER FAVOURITE MODEL. IN 1912 ELBE AND GOTTLIEB MOVED TO PARIS WHERE ELBE COULD LIVE MORE OPENLY AS A WOMAN. THEY WENT TO BALLS AND PARTIES TOGETHER AND TOLD PEOPLE ELBE WAS GOTTLIEB'S SISTER.

"I said to myself that as my case has never been known in the history of the medical art, it simply did not exist, it simply could not exist"

ELBE VISITED MANY DOCTORS WHO DIAGNOSED HER AS GAY OR HYSTERICAL.

IN THE 1920's THERE WERE STUDIES ABOUT HOMOSEXUALITY. MAGNUS HIRSCHFELD WAS A GERMAN JEWISH PHYSICIAN AN SEXOLOGIST AND ONE OF THE FIRST ADVOCATES FOR HOMOSEXUAL AND TRANSGENDER RIGHTS. MAGNUS WANTED SEXOLOGY TO TURN INTO AN ACADEMIC DISCIPLINE. HE KNEW THERE WERE PEOPLE WHO WANTED TO CHANGE THEIR SEX. HE CALLED IT "TRANSSEXUALISMUS".

IN 1930 ELBE WENT TO DRESDEN FOR HER SURGICALLY TRANSITION, ONE OF THE FIRST OF ITS KIND. THIS WAS AN EXPERIMENTAL TREATMENT BUT SHE WAS VERY EXCITED ABOUT MAKING HER DREAM COME TRUE.

ELBE AND GOTTLIEB WERE DIVORCED AT THIS TIME. ELBE WAS ENGAGED TO A MAN.

ELBE HAD FOUR SURGERIES BY DR. KURT WARNEKROS. DURING THESE SURGERIES SHE LOST MANY FRIENDS. HER LAST SURGERY CONSISTED OF A UTERUS IMPLANT AND THE CONSTRUCTION OF A VAGINA. HER BODY ULTIMATELY REJECTED THE UTERUS IMPLANT AND ELBE DIED THREE MONTHS LATER AFTER HER FOURTH AND FINAL SURGERY.

IT HAS BEEN THOUGHT AFTERWARDS THAT LILI PROBABLY WAS AN INTERSEX PERSON AS SHRUNKEN OVARIES WERE FOUND IN HER BODY DURING THE AUTOPSY.

WEIBLICHER FORTPFLANZUNGAPPARAT

LILI'S LIFE WAS DOCUMENTED IN DAVID EBERSHOFF'S NOVEL "THE DANISH GIRL", WHICH WAS INSPIRED IN THE BIOGRAPHY "MAN INTO WOMAN" WRITTEN BY NIELS HOYER.

THERE IS NOT MUCH INFORMATION ABOUT LILI'S MEDICAL PROCEDURES, AS THE INSTITUTE FOR SEXUAL RESEARCH, FOUNDED BY MAGNUS HIRSCHFELD, WAS DESTROYED BY NAZIS IN 1933.

"That I, Lili, am vital and have a right to life I have proved by living for 14 months. It may be said that 14 months is not much, but they seem to me like a whole and happy human life"

CLARA
BOW

29TH JULY 1905, BROOKLYN, NYC, U.S. →→ SHE GREW UP IN CONEY ISLAND

27TH SEPTEMBER 1965, CULVER CITY, CALIFORNIA, U.S.

"IT GIRL" WAS ORIGINALLY SLANG FOR A BEAUTIFUL, STYLISH, YOUNG WOMAN, WHO POSSESSED SEX APPEAL WITHOUT FLAUNTING HER SEXUALITY. THE PHRASE ORIGINATED IN BRITISH UPPER-CLASS SOCIETY AROUND THE TURN OF THE 20TH CENTURY.

(ETHERINGTON-SMITH, MEREDITH AND PILCHER, JEREMY, THE "IT" GIRLS (1986), 241.)

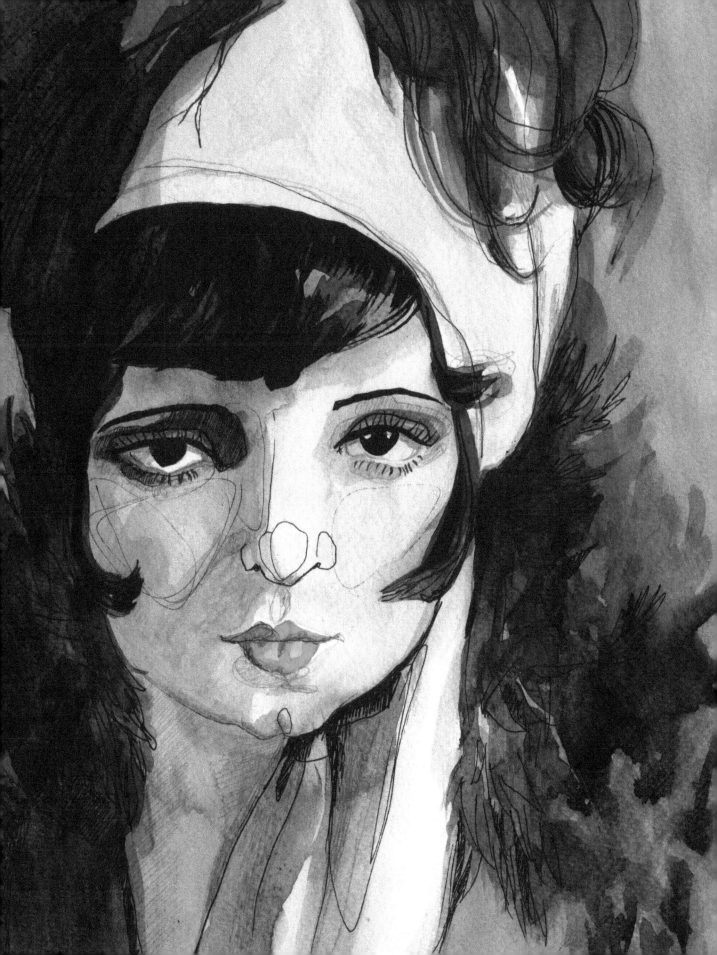

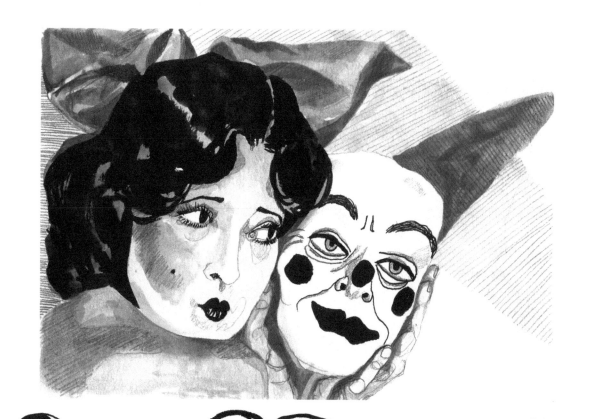

THE RED-HAIRED CLARA BOW WAS THE FIRST "IT-GIRL" IN HISTORY.
THE PHRASE FIRST APPEARED IN A SHORT STORY
BY RUDYARD KIPLING IN 1904,
BUT IT BECAME POPULAR IN 1927 FOLLOWING THE FILM "IT",
WRITTEN BY ELINOR GLYN. PARAMOUNT STUDIOS GAVE CLARA BOW THE
ROLL OF THE MAIN CHARACTER IN THIS MOVIE,
AND SHE CAPTURED PEOPLE BY HER PERFORMANCE.
HER SEDUCTIVE NATURE, ENERGETIC AND INDEPENDENT,
TOGETHER WITH HER SHORT HAIR AND SHORT SKIRTS, MADE HER THE
PERFECT EXAMPLE OF A MODERN WOMAN. SHE BECAME ONE OF THE FIRST
SEX SYMBOLS OF THE FILM INDUSTRY, OPENING THE DOOR TO FUTURE
BEAUTIFUL BOMBSHELLS LIKE MARILYN MONROE AND MAE WEST.

BOW WAS BORN INTO A POOR FAMILY IN BROOKLYN. HER CHILDHOOD
WAS VERY DIFFICULT. HER MOTHER WAS AN OCASSIONAL PROSTITUTE
WHO SUFFERED SCHIZOPHRENIA AND HER FATHER SEXUALLY ABUSED
BOTH BOW AND HER MOTHER.
YEARS LATER, BOW WON AN ACTING COMPETITION AND WORKED IN
MOVIES PLAYING SUPPORTING ROLES.

AFTER STARRING IN THE FILM "IT" BOW BECAME FAMOUS. SHE ACTED IN THE MOVIE "WINGS", WICH WON THE FIRST ACADEMY AWARD FOR BEST PICTURE IN 1929.

HER REPUTATION OF FEMME FATALE BROUGHT BOW'S PERSONAL LIFE TO THE TABLOIDS. SHE REPORTEDLY HAD LOVERS LIKE GARY COOPER, BELA LUGOSI, AND JOHN WAYNE.

to: Clara Bow

SHE ONCE RECEIVED 45.000 FAN LETTERS IN A MONTH

BUT HOLLYWOOD OF THE 1930s WASN'T FOR BOW. SHE RETIRED FROM ACTING WHEN SHE WAS 27 YEAS OLD.

SOME CONSIDER BOW AS ONE OF MANY SILENT FILM STARS WHO HAD A CAREER THAT WAS HURT WITH THE ADVENT OF SOUND IN FILM. PEOPLE SAID IT WAS HER STRONG BROOKLYN ACCENT, BUT SCANDALS, GAMBLING DEBT, AN EATING DISORDER, AND ALCOHOL AND PRESCRIPTION DRUG DEPENDENCIES ULTIMATELY HURT BOW'S CAREER.

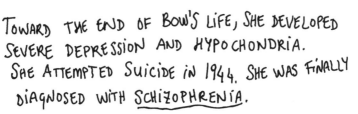

TOWARD THE END OF BOW'S LIFE, SHE DEVELOPED SEVERE DEPRESSION AND HYPOCHONDRIA. SHE ATTEMPTED SUICIDE IN 1944. SHE WAS FINALLY DIAGNOSED WITH SCHIZOPHRENIA.

BOW DIED OF A HEART ATTACK AT THE AGE OF 60.

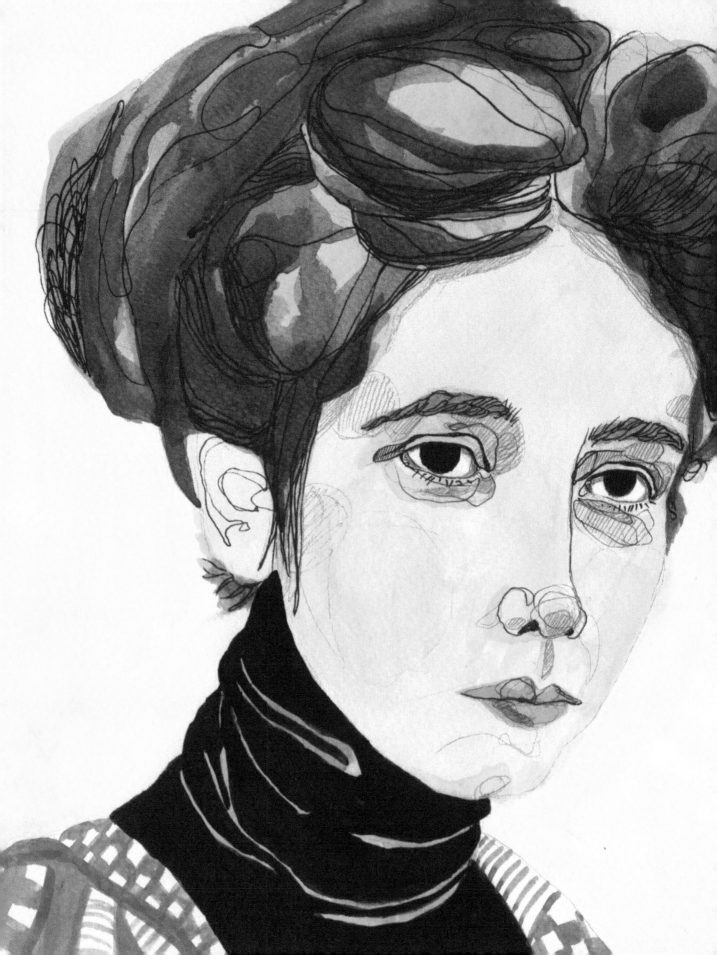

MARÍA LEJÁRRAGA

28TH DECEMBER 1874, SAN MILLÁN DE LA COGOLLA, LA RIOJA, SPAIN—
28TH JUNE 1974, BUENOS AIRES, ARGENTINA

MARÍA DE LA O LEJÁRRAGA GARCÍA WAS A SPANISH WRITER, FEMINIST ESSAYIST AND SOCIALIST POLITICIAN. SHE WAS MARRIED TO GREGORIO MARTÍNEZ SIERRA, AN ACCLAIMED DRAMATIST IN THE SPANISH THEATRICAL AVANT-GARDE. GREGORIO WAS THE SIGNER OF MANY SUCCESSFUL PLAYS. OR TO PUT IT ANOTHER WAY, HE SIGNED THEM WHEREAS MARÍA WROTE THEM.

MARÍA DE LA O

IN THE 20TH CENTURY, WOMEN'S ORGANIZATIONS ADVOCATED THE EXTENSION OF THE "FRANCHISE", THE RIGHT TO VOTE IN PUBLIC ELECTIONS, TO WOMEN. IN SPAIN, WHICH IN THIS TIME WAS AN ULTRACONSERVATIVE COUNTRY, FEMINISM AND THE RIGHT TO VOTE IN PUBLIC ELECTIONS WAS NOT WIDELY SUPPORTED.

MARÍA LEJÁRRAGA WAS A SCHOOL TEACHER WHO LOVED LITERATURE. SHE PUBLISHED A BOOK FOR CHILDREN, THIS WOULD BE HER "ONLY" BOOK (UNDER HER NAME).
WHEN LEJÁRRAGA WAS 26 SHE MARRIED GREGORIO. MARRIAGE WAS THE ONLY WAY FOR WOMEN TO BE EMANCIPATED FROM THEIR FAMILIES.

THEY MADE A LIVING TOGETHER FROM MARÍA'S SALARY. SHE WORKED AT THE SCHOOL DURING THE DAY AND WROTE NOVELS AND PLAYS UNDER GREGORIO'S NAME DURING THE NIGHT.
GREGORIO DEDICATED HIMSELF TO OTHER BUSINESSES LIKE PRODUCING CULTURAL MAGAZINES AND CREATING THE EDITORIAL "RENACIMIENTO."
IN 1906 GREGORIO BROKE MARÍA'S HEART 💔 HE HAD AN AFFAIR WITH CATALINA BÁRCENA, A FAMOUS AND BEAUTIFUL ACTRESS. BUT THEY REMAINED MARRIED.

"CANCIÓN DE CUNA" AND SUCCESS

IN 1911 THE PLAY "CANCIÓN DE CUNA" WAS A SUCCESS, AND WAS ADAPTED FOR THE HOLLYWOOD BIG SCREEN WITH SEVERAL OTHER PLAYS.

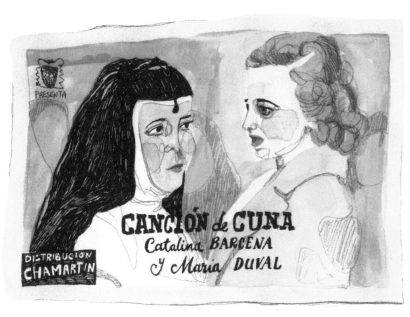

GREGORIO SET UP HIS OWN THEATRE COMPANY AND PUSHED MARÍA TO WRITE AS MUCH AS SHE COULD.
WHEN GREGORIO'S MISTRESS, CATALINA, GOT PREGNANT, MARÍA SEPARATED FROM GREGORIO.
IN 1930 GREGORIO SIGNED A DOCUMENT IN WHICH HE DECLARED MARÍA AS A COLLABORATOR AND CO-WRITER IN ALL HIS WORK TO LIVE ON THE ROYALTIES.

MARÍA WAS ALSO AN ACTIVE POLITICIAN IN THE SOCIALIST PARTY DURING THE SECOND SPANISH REPUBLIC. SHE WAS ELECTED TO CONGRESS IN GRANADA IN 1933 (FIRST TIME WOMEN WOULD VOTE FOR ELECTIONS IN SPAIN).
SHE WAS A FEMINIST, AND PARADOXICALLY, WROTE FEMINIST SPEECHES FOR HER HUSBAND GREGORIO.

WHEN THE SPANISH CIVIL WAR BEGAN (AFTER THE SPANISH COUP OF JULY 1936, SUPPORTED BY THE NAZY GERMANY AND ITALIAN FASCISM), THE FIGHT FOR HUMAN RIGHTS WAS SILENCED AND MARÍA WENT INTO EXILE TO FRANCE. GREGORIO TRAVELLED TO ARGENTINA. IN 1947, HE DIED LEAVING 50% OF THE COPYRIGHT OF MARÍA'S WORK TO CATALINA'S DAUGHTER.

WHEN SHE WAS 78 MARÍA STATED SHE WAS AN AUTHOR OF HER HUSBAND'S WORK IN HER AUTOBIOGRAPHY "GREGORIO Y YO" FOR THREE REASONS: • HER FAMILY DIDN'T APROVE HER FIRST BOOK, • BEING A TEACHER AND A WRITER WASN'T LOOKED AT FAVORABLY, • AND THE THIRD REASON WAS LOVE.
LEJÁRRAGA TALKS IN HER AUTOBIOGRAPHY ABOUT 'COLLABORATION'. FURTHER INVESTIGATIONS HAVE REVEALED THAT GREGORIO'S COLLABORATION WAS VERY RARE.

AMELIA EARHART

24TH JULY 1897, ATCHISON, KANSAS, U.S. —
DISAPPEARED AT THE PACIFIC OCEAN ON THE 2ND OF JULY 1937

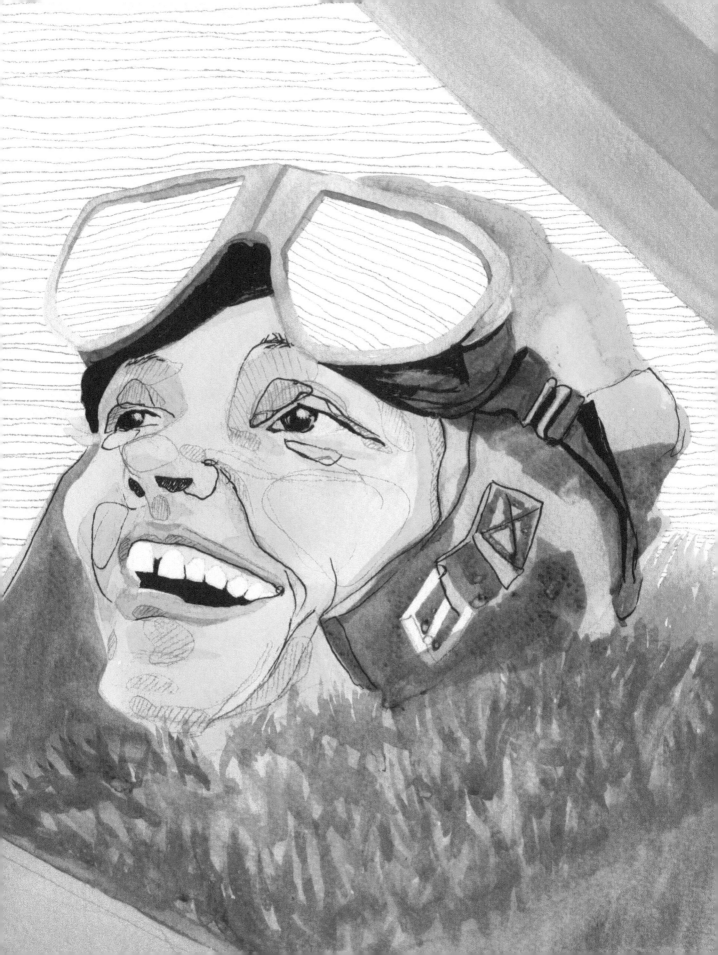

AMELIA MARY EARHART WAS AN AMERICAN AVIATION PIONEER AND THE FIRST FEMALE AVIATOR TO FLY SOLO ACROSS THE ATLANTIC OCEAN. EARHART'S MOTHER, AMELIA "AMY" EARHART, WANTED HER TO BE "A PROPER LADY", BUT THIS AMBITIOUS GIRL AVOIDED THE CONVENTIONAL LIFE OF A WOMAN.
SHE LOVED RIDING PONIES, CLIMBING TREES, GOING SLEEDING WITH HER SISTER. SHE ALSO COLLECTED NEWSPAPER CLIPPINGS ABOUT WOMEN WHO EXCELLED IN ACTIVITIES TRADITIONALLY VIEWED MORE SUITABLE BY MEN.

EARHART'S LOVE FOR FLYING STARTED WHEN SHE VISITED AN AIRFIELD WITH HER FATHER AT THE AGE OF 23.
AFTER HER FIRST AVIATION LESSONS WITH FEMALE AVIATOR PIONEER NETA SNOOK, EARHART CUT HER HAIR AND BOUGHT A LEATHER JACKET.

SHE SLEPT IN HER JACKET FOR 3 NIGHTS TO GIVE IT A "WORN" LOOK.

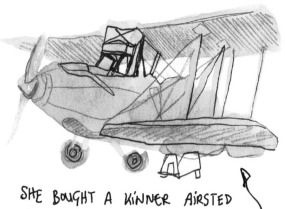

SHE BOUGHT A KINNER AIRSTED BIPLANE, PAINTED IT IN YELLOW, AND NICKNAMED IT "THE CANARY"

IN 1923 SHE WAS THE 16TH WOMAN TO EARN HER PILOT'S LICENSE BY THE FÉDÉRATION AÉRONAUTIQUE INTERNATIONALE.

THE CALL

IN 1928 AMERICAN PUBLISHER, AUTHOR AND EXPLORER GEORGE PUTNAM WAS HIRED TO FIND AN APPROPRIATE WOMAN TO BE THE FIRST ONE IN CROSSING THE ATLANTIC OCEAN.
EARHART WAS CHOSEN TO FLY ACROSS THE ATLANTIC WITH PILOT WILMER STULTZ AND MECHANIC LOUIS GORDON, THE AIRPLANE WAS CALLED "FRIENDSHIP!"

THEY LANDED IN SOUTH WALES ON 17TH OF JUNE 1928,
20 HOURS AND 40 MINUTES AFTER DEPARTING FROM
CANADA. PEOPLE WELCOMED THEM AND CHEERED
EARHART. HOWEVER, EARHART FELT EMBARRASSED.
SHE CONSIDERED SHE HAD DONE NOTHING DURING THE FLIGHT.
 SHE SAID:

 "I was just baggage, like a sack of potatoes."

AFTER THE FLIGHT GEORGE P. PUTNAM MANAGED
EARHART'S CAREER.
EARHART BECAME A CELEBRITY AND EARNED THOUSANDS
OF DOLLARS SPONSORING PRODUCTS. PUTNAM PROPOSED
TO EARHART SIX TIMES BEFORE SHE FINALLY AGREED.
SHE KEPT HER MAIDEN NAME, EARHART.
IN 1932 SHE FLEW SOLO THE ATLANTIC, BEING THE
SECOND PERSON DOING IT AFTER CHARLES A. LINDBERGH.

LUCKY
STRIKE
CIGARETTES

Amelia M. Earhart

"It's toasted" Reach For a slender figure—
for a lucky instead of a sweet
No Throat Irritation - No Cough.

EARHART ALWAYS USED HER
FAME TO DEFEND INCORPORATION
OF WOMAN TO THE FIELD
OF AVIATION.

1936. AMELIA'S LAST CHALLENGE: A FLIGHT AROUND
THE WORLD FOLLOWING A TOUGH EQUATORIAL ROUTE.

17TH MARCH 1937
- AIRPLANE: LOCKHEED ELECTRA 10E
- CREW: AMELIA / FRED NOONAN /
 HARRY MANNING / MANTZ

← MANNING AND MANTZ
 GAVE UP THE EXPEDITION
 AT THIS POINT

2ND JULY 1937
DURING AN ATTEMPT TO MAKE A
CIRCUMNAVIGATIONAL FLIGHT
OF THE GLOBE IN 1937 IN A
PURDUE-FUNDED LOCKHEED MODEL 10-5
ELECTRA, EARHART DISAPPEARED
OVER THE CENTRAL PACIFIC
 OCEAN NEAR
 HOWLAND ISLAND.

ITASCA, THE PICKET SHIP IN CHARGE OF PROVIDING AIR NAVIGATION
AND RADIO FROM HOWLAND ISLAND RECEIVED A
RADIO MESSAGE FROM EARHART.
BUT THE AVIATORS WERE UNABLE TO HEAR THE RETURN TRANSMISSIONS.
EARHART AND NOONAN VANISHED.

THERE ARE MANY THEORIES ABOUT WHAT HAPPENED TO EARHART.
BUT THE FINAL CONCLUSION WAS THAT EARHART HAD GONE DOING
WHAT SHE LOVED THE MOST. FLYING.

MARGARET MEAD

16TH DECEMBER 1901, PHILADELPHIA, PENNSYLVANIA, U.S.—
15TH NOVEMBER 1978, NEW YORK CITY, U.S.

MARGARET MEAD WAS AN AMERICAN CULTURAL ANTHROPOLOGIST, AUTHOR, AND SPEAKER IN THE MASS MEDIA DURING THE 1960's AND 1970's.

WORK IS WHAT MARGARET MEAD LIKED TO DO THE MOST.
WHEN SHE WAS YOUNG, THE ROARING TWENTIES WERE IN FULL SWING, BUT MEAD LIKED GOING TO BED EARLY, AND GOT UP AT 5:00AM TO DEDICATE HER DAY TO HER STUDIES.

THE LIBRARY OF COLUMBIA UNIVERSITY

"I learned the value of hard work by working hard."

MEAD GREW UP IN A FAMILY OF INTELECTUALS. HER FATHER WAS AN ECONOMIST AND HER MUM A SOCIOLOGIST WHO STUDIED ITALIAN INMIGRANTS FAMILIES' BEHAVIOR.

WHEN SHE WAS 11 MEAD INSISTED ON BEING BAPTIZED, EVEN THOUGH HER PARENTS WEREN'T RELIGIOUS.
MARGARET WAS A HUMAN RIGHTS ACTIVIST AND A FEMINIST. HER WORK HAD A HUGE IMPACT IN THE FIELD OF ANTHROPOLOGY.

MARGARET MEAD:

- PUBLISHED 40 BOOKS.
- WROTE 1,400 ARTICLES.
- COMPILED RECORDS AND FILMS ABOUT DIFFERENT CULTURES FROM HER TRIPS.
- PROFESSOR AT RENOWNED UNIVERSITIES, LIKE COLUMBIA, FORDHAM AND RHODE ISLAND.
- EXECUTIVE SECRETARY OF THE NATIONAL RESEARCH COUNCIL'S COMMITTEE ON FOOD HABITS.
- CURATOR OF ETHNOLOGY AT THE AMERICAN MUSEUM OF NATURAL HISTORY.
- PRESIDENT OF THE AMERICAN ANTHROPOLOGICAL ASSOCIATION.
- VICE PRESIDENT OF THE NEY YORK ACADEMY OF SCIENCES.
- PARTICIPANT IN THE AMERICAN ASSOCIATION OF THE ADVANCEMENT OF SCIENCE.

MEAD WAS AN ADVOCATE FOR NEW FIELDS OF STUDY IN ANTHROPOLOGY (IT WAS A NEW SCIENCE BY THAT TIME). SHE STUDIED, DISCUSSED, AND WROTE ABOUT TOPICS LIKE GENDER AND EDUCATION. IN 1928, MEAD'S CONTROVERSIAL BOOK "COMING OF AGE IN SAMOA", A STUDY OF THE ADOLESCENT GIRLS FROM THE ISLAND OF TA'U, BECAME A BEST-BELLER.

AFTER TRAVELLING TO SAMOA, MEAD WENT TO BALI AND NEW GUINEA TO STUDY EIGHT DIFFERENT CULTURES.

MEAD LOVED CONDUCTING FIELD WORK AND SHE DEFENDED CULTURAL DIVERSITY AS A RESOURCE.

WHEN SHE WAS 77 SHE WAS DIAGNOSED WITH PANCREAS CANCER BUT CONTINUED TO WORK THROUGH TREATMENT.

SIX MONTHS LATER, ON THE 15TH OF NOVEMBER 1978, MEAD DIED.

THE NEW YORK TIMES EDITORIAL WOULD REFER TO HER AS "THE GRANDMOTHER OF THE WORLD."

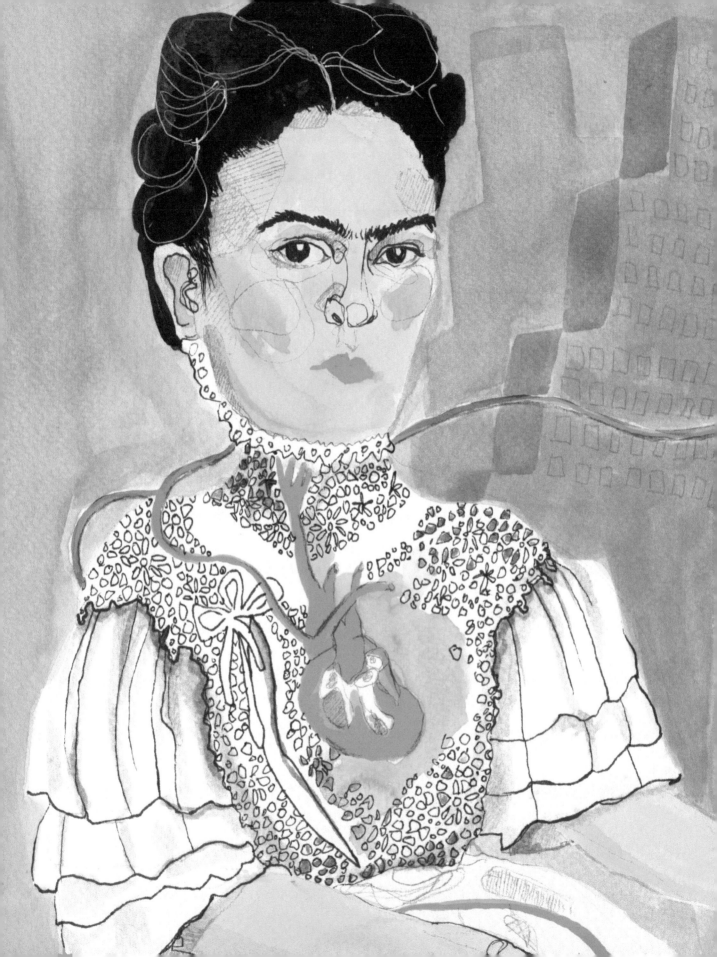

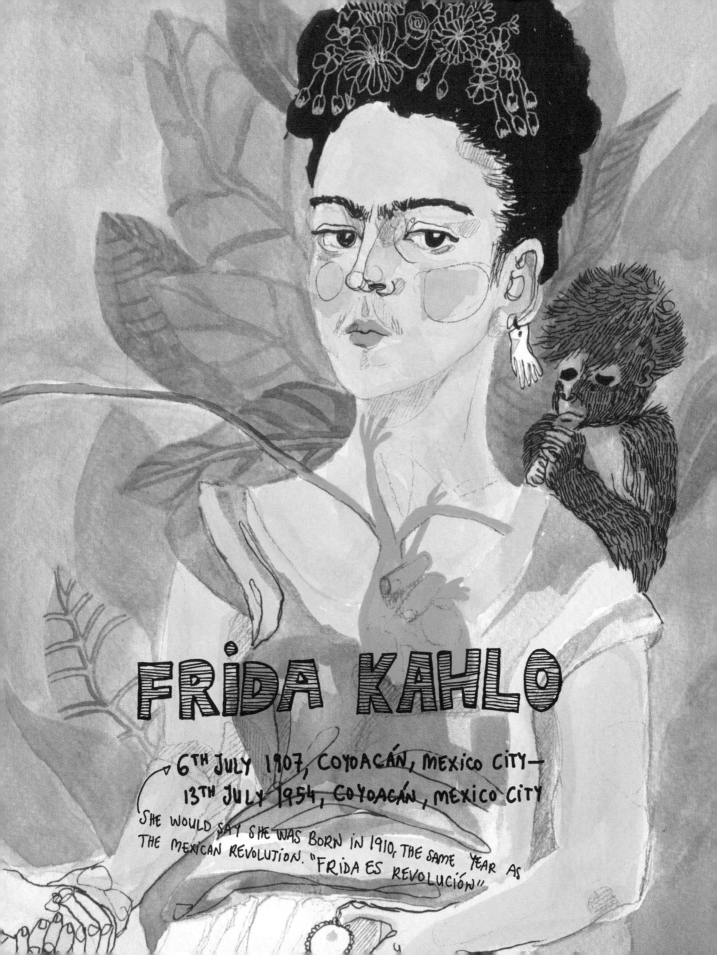

FRIDA KAHLO

6TH JULY 1907, COYOACÁN, MEXICO CITY—
13TH JULY 1954, COYOACÁN, MEXICO CITY
SHE WOULD SAY SHE WAS BORN IN 1910, THE SAME YEAR AS
THE MEXICAN REVOLUTION. "FRIDA ES REVOLUCIÓN"

FRIDA SPENT MUCH OF HER LIFE IN BED IN "LA CASA AZUL" (THE BLUE HOUSE).

SHE WAS DISABLED BY POLIO AS A CHILD AT AGE 6. CHILDREN AT THE SCHOOL CALLED HER "FRIDA KAHLO, PATA DE PALO" (FRIDA PEG LEG).

AT THE AGE OF 18, FRIDA'S SCHOOL BUS CRASHED INTO A TROLLEY CAR. SHE WAS BADLY INJURED. HER SPINE WAS BROKEN IN THREE PARTS, HER RIGHT LEG HAD ELEVEN FRACTURES, HER FOOT, COLLARBONE, PELVIS AND A FEW RIBS WERE BROKEN.

THIS TRAGIC ACCIDENT MARKED FRIDA'S LIFE FOREVER, MAKING IT IMPOSSIBLE FOR HER TO HAVE CHILDREN.
SHE HAD SEVERAL MISCARRIAGES.
IN 1953 HER LEG WAS AMPUTATED DUE TO GANGRENE.
FRIDA'S BODY BECAME THE MAIN SUBJECT OF HER ART WORK.

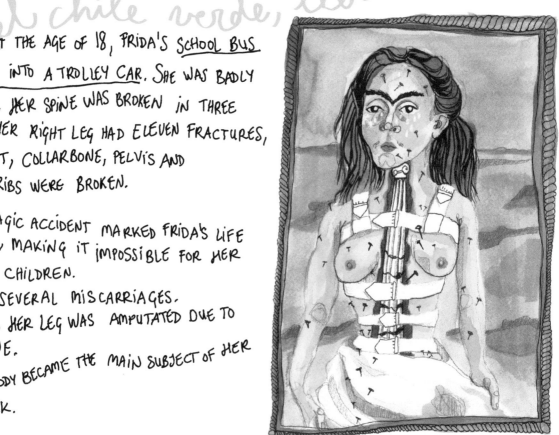

*"THE BROKEN COLUMN", 1944

66

LOVE, THE FROG

"There have been two great accidents in my life. One was the trolley, and the other was Diego. Diego was by far the worst."

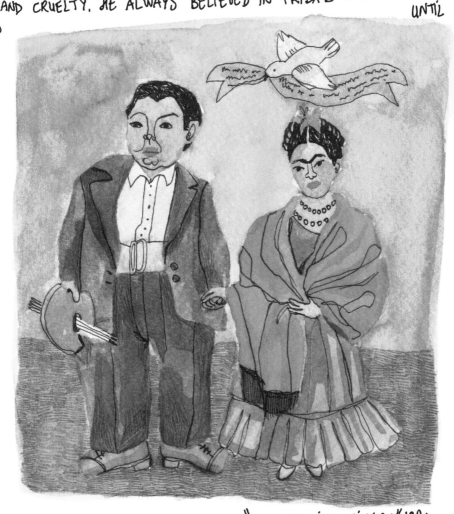

<u>DIEGO RIVERA</u> WAS THE MOST CELEBRATED MURAL PAINTER IN MEXICO DURING REVOLUTIONARY TIMES.

<u>FRIDA MARRIED RIVERA TWICE.</u> THEY WERE DIVORCED ONCE DUE TO DIEGO'S INFIDELITY WITH FRIDA'S SISTER, CRISTINA. DIEGO ONCE SAID HIS DOCTOR DIAGNOSED HIM AS INCAPABLE OF MONOGAMY. FRIDA ALSO HAD <u>SEVERAL LOVERS</u>, BOTH MEN AND WOMEN: LEON TROTSKY, ISAMU NOGUCHI, CHAVELA VARGAS, AND NICKOLAS MURAY. BUT RIVERA WAS ALWAYS IN FRIDA'S HEART. THEIR LOVE WAS A MIX OF LOVE AND CRUELTY. HE ALWAYS BELIEVED IN FRIDA'S TALENT AND SUPPORTED HER UNTIL SHE DIED.

Diego

FRIDA USED TO CALL HIM FROG

* "FRIDA Y DIEGO RIVERA," 1931

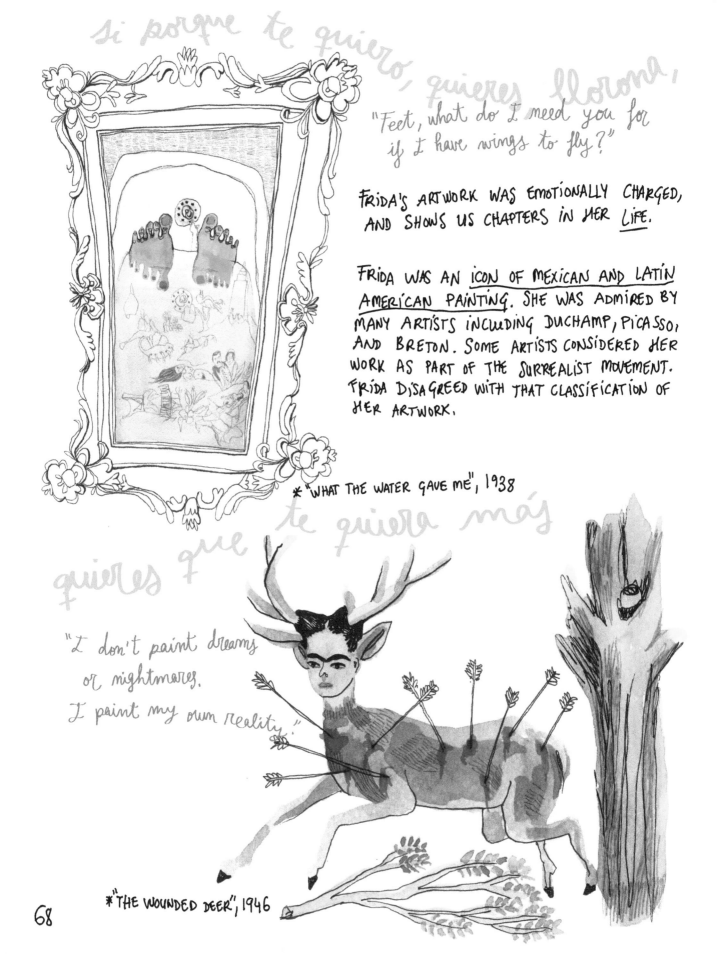

si porque te quiero, quieres llorona,

"Feet, what do I need you for
if I have wings to fly?"

FRIDA'S ARTWORK WAS EMOTIONALLY CHARGED,
AND SHOWS US CHAPTERS IN HER <u>LIFE</u>.

FRIDA WAS AN <u>ICON OF MEXICAN AND LATIN
AMERICAN PAINTING</u>. SHE WAS ADMIRED BY
MANY ARTISTS INCLUDING DUCHAMP, PICASSO,
AND BRETON. SOME ARTISTS CONSIDERED HER
WORK AS PART OF THE SURREALIST MOVEMENT.
FRIDA DISAGREED WITH THAT CLASSIFICATION OF
HER ARTWORK.

* "WHAT THE WATER GAVE ME", 1938

quieres que te quiera más

"I don't paint dreams
or nightmares.
I paint my own reality."

*"THE WOUNDED DEER", 1946

68

Viva la vida

IN 1953, LESS THAN A YEAR BEFORE FRIDA DIED, SHE COMPLETED HER FIRST MAJOR EXHIBITION IN MEXICO. FRIDA WAS SO ILL AT THE TIME SHE COULDN'T LEAVE HER BED TO GO TO THE EXHIBITION.

SHE ENTERED THE GALLERY IN A HOSPITAL STRETCHER TO HER FOUR-POST BED. HER BED HAD A MIRROR AFFIXED TO THE UNDERSIDE OF THE CANOPY, WHICH SHE USED TO PAINT HER SELFPORTRAITS. AT THE HEADBOAR THERE WERE PHOTOS OF HER HUSBAND, DIEGUITO, FAMILY, AND POLITICAL HEROES: STALIN, MARX, ENGELS, AND MAO. A PAPIER-MACHÉ SKELETON HANGED FROM THE CANOPY.

FRIDA DRESSED HER FAVOURITE MEXICAN COSTUME AND HER JEWELS. FRIDA SHOWED HER "ALEGRÍA" ONCE MORE, SINGING MEXICAN BALLADS WITH HER FRIENDS AND ADMIRERS AROUND HER BED.
IN 1954 FRIDA DIED, SHE WAS 47.

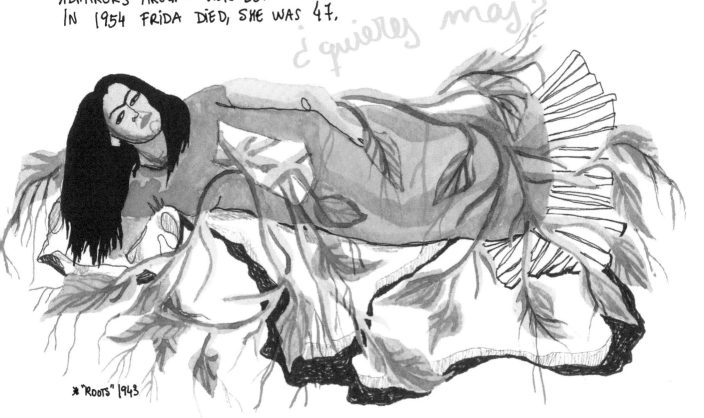

* "ROOTS" 1943

* THESE DRAWINGS ARE A REINTERPRETATION OF FRIDA'S PAINTINGS.

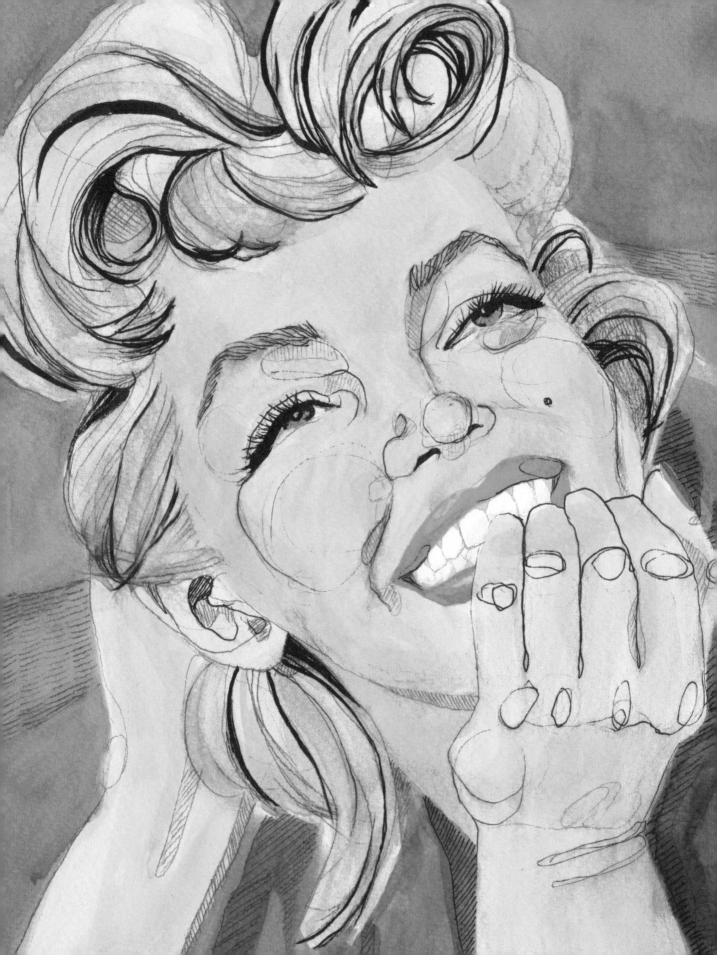

MARILYN MONROE

1ST JUNE 1926, LOS ANGELES, CALIFORNIA, U.S.—
5TH JUNE 1962, LOS ANGELES, CALIFORNIA, U.S.

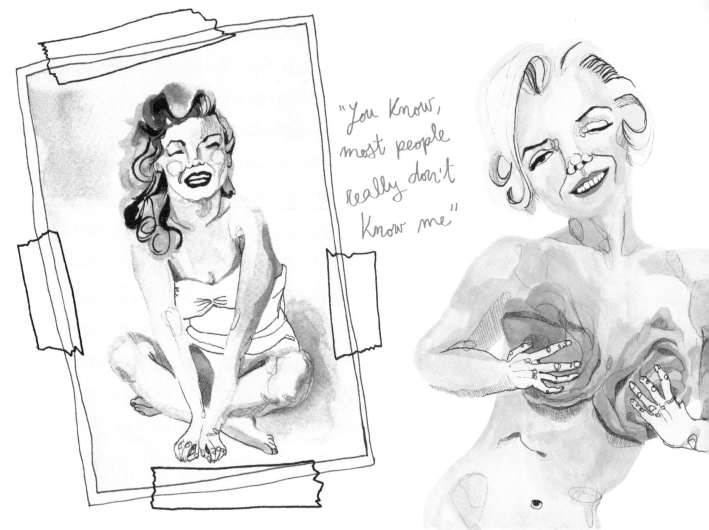

"You know, most people really don't know me"

"I'm trying to find myself as a person, sometimes thats not easy to do. Millions of people live their entire lives without finding themselves. But it is something I must do. The best way for me to find myself as a person is to prove myself that I am an actress"

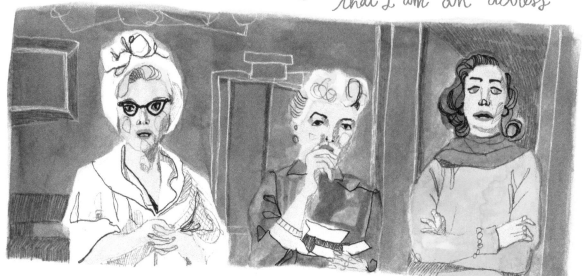

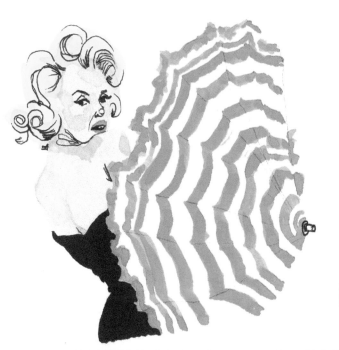

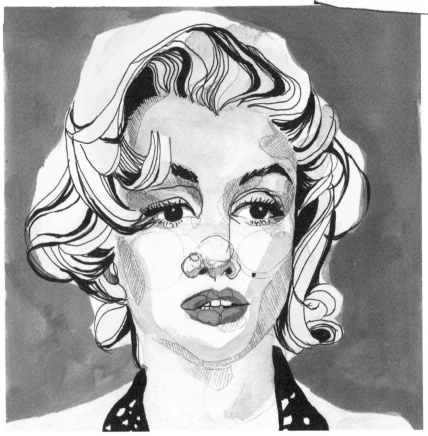

"Could never
pretend something
I didn't feel.
I could never
make love,
if I didn't love,
and if I loved
I could no more
hide the fact
than change
the color of
my eyes"

"Hollywood is a place where they'll pay you a thousand dollar for a kiss and fifty cents for your soul"

...nes), Barb...

...Witty (Jaworska), Ros...

Peggy Woolven (Japing)

D.E.R. Johnstone-Hogg

Iris Joint (Kramer), N.

Lilian Jones (Buchanan),

Jones, Patricia Jones (Hat...

Alwayne W. Jones, Amy Claire M.

Margaret Jones, Barbara Clariss...

Elisabeth M. Jones, Esther P. Jones,

Freda M. Jones (Rose), G.H.B. Jones, G.

Gwendoline Mary Jones (Field), H. Jones, H...

Jane Jones, Joyce Ingman Jones (Conway), Joyce

Marion Jones (Stevens), M. Jones, M.E. Jones,

M.G. Jones, Mair Jones (Winfield), Margaret

Jones (Gregory), Margery Jones (Andrews),

...ureen Mary Jones, Mavis Jones, Megan

...(Williams), P.F.V. Jones, P.M. Jones,

...s Margaret Jones, Phyllis E. Jones

...nson), Phylliss Margaret Jones (Bean),

... Ruth L. Jones (Tyers), Ruth Jones

Margaret Lovelace Britton (Jenks...

Freda Cooper (Jones), Rita M. Cow...

Cecily Mary Dalrymple-Hay (

J. Daniels (Jones), Norma M.

(Johnson), Dorothy Davison

A. Dewar (Johnston), Do...

Marjorie Elliott (Jelinek...

Evans (Jones), Adrienn

(Jackson), Ruth Mary

Iris Cynthia Fossey (

Freeman (Jeffries),

Helen Tatiana Gree...

Jabez-Smith (Alf...

(Bull), Beryl J

G. Jackson, Joa...

Jackson (Barr...

M.A.J. Jack

Jackson (

P.N. Jack

Norah (

(Parso...

Const...

Hu...

(...

...(Smith),

...), Barbara

... Doreen M. Tipler

...na Tilyard (Ellan), F.M. Tinn...

Eileen Tilley (Sarjeant), Rhona L.

...uge, Jane E. Woodcock,

...(Burris), Josephine Barbara

..., Angela M. Woodin, Barbara Ellen

Woodman (Beach), Stella Marry Wendy Woodman-

Smith, M.B.K. Woodrow, F.O. Civilian Woods

E.Th...

Dr...

Th...

Ne...

...an Isob...

...an Witty

...gy W...

WOMEN CODEBREAKERS

Audrey Abbot, Hilda Abbot, Barbara
(Eachus), Jeanne Effie Ablitt, J.L.T Abraham,
Audrey Abrahams, Sylvia Abrahams (Braham),
Joy Absalom (Davis), Gwendoline May Acason
(Page), N. Adair (Wriht), N.E. Adair, P.M. Adair,
Shirley Margaret Frances Adair (Capper), D.N.
Adams, Elsie Janet Adams (Wright), E.M. Adams,
Elizabeth Isabel Adams (Dawson), H.M. Adams,
Adams, J.Hilary M. Adams (McDowall), Margot
ms (Corbett), Mary Adams, Noreen E. Adams
b), Sally Adams (Dawson), Sheila Adams,
garet E. Adamson, Margaret M. Adie, Betty
Dot Agnesetti, Gladys Mary Agnew
Stella Ahrens (Sandford), J.C.S.
Akers, S.D.M. Albrecht, Elizabeth
Alcock (Bolingbroke-Kent), Margar
Ethel Alderman (Andruszewi
Aldrid
Gordon
J. Alexander, M.O. Alexander, Pe
Joan Alexander (Fr an Alingt
 Page),
oward), Barbara Johnst llan
Elizabeth Allan (Dur
() Nancy A

Monic
Davies
), Elizabeth
ards (Jones),
ence Myra
nbergh Farrell
d Fletcher (Jenkins),
Norma Adelaide
fred Glover (Joslin),
), Vivienne L.
nifred May Jackman
Dorothy Jackson (Lankester),
(Hunter), Joy Maisie
Jackson, Anna
Jackson (Fletcher)
J.Jackson,
Nora Mary Jackson
uth Jackson
rtland), Elizabeth
her Jane Jaffe, Shei
ez, James, D. James, E.F.E James
s (Richards), Heather Catesby James
J.M. James, Joan Margaret James,

M.E.Baker, Nancy Isobel Baker (Lynn), Pat
Baker, V.J. Balance, Joan E. Balch (Stevens),
Constance M. Balcomb (Nishio), E.D. Balcombe,
H.J. Baldi, Mary Ross Baldock (Glenfield),
Daphone Elizabeth Dorothy Baldwin (Child), K.B.

Thelma Ena Louise
Nancy Woodcock (Bur
odford, Angela M. Wo
an (Beach), Stell
M.B.K. Wood

MAY 8, 1945 MARKED THE FORMAL ACCEPTANCE BY THE ALLIES OF NAZI GERMANY'S UNCONDITIONAL SURRENDER. WORLD WAR II ENDS IN EUROPE. THE DATE IS ANNOUNCED AS V-DAY (VICTORY IN EUROPE).

ON SEPTEMBER 2, 1945 AFTER THE U.S. DROPPED HIROSHIMA AND NAGASAKI BOMBS, JAPAN SURRENDERS AND WORLD WAR II ENDS.

WWII WAS THE DEADLIEST CONFLICT IN HISTORY OF HUMANITY MARKED BY 50 TO 70 MILLION FATALITIES.

DURING THE WAR, <u>BLETCHLEY PARK</u> (50 MILES NORTH WEST LONDON) WAS THE CENTRAL SITE FOR BRITISH CODEBREAKERS. IT HOUSED THE GOVERNMENT CODE AND CYPHER SCHOOL.
IT WAS AT BLETCHLEY PARK WHERE THE CODEBREAKERS OPERATORS DECIPHERED NAZI SIGNALS, BREAKING ENIGMA AND LORENZ CODES. THESE EFFORTS HELPED TO SHORTEN THE WAR BY TWO OR THREE YEARS AND <u>SAVED THOUSANDS OF LIVES</u>.

WHO WERE THE <u>WOMEN CODEBREAKERS</u>?

POLISH INTELLIGENCE SERVICES KNEW ABOUT THE NAZI INVASION, AND SHARED THEIR "<u>ENIGMA</u>" REPLICAS AND WORK ON DECIPHERING NAZI CODES WITH THE U.K. AND FRANCE. "ENIGMA" WAS A MACHINE INVENTED BY GERMANS TO SEND CODE MESSAGES.
THE CENTRAL SITE FOR THE BRITISH CODEBREAKERS IN BLETCHLEY PARK WAS KEPT A <u>SECRET</u>.
RECRUITED EMPLOYEES <u>WERE</u> REQUIRED TO SIGN AN OFFICIAL SECRETS ACT, WHICH <u>FORBADE</u> THEM FROM TALKING ABOUT THEIR WORK AND SITE.
THE <u>PUBLIC DIDN'T KNOW</u> ABOUT BLETCHLEY PARK UNTIL THE <u>1970s</u>.

CARELESS TALK COSTS LIVES

THIS PHRASE ABOUT MAINTAINING SECRECY DISCOURAGED PEOPLE TALKING ABOUT SENSITIVE MATERIAL WHERE IT COULD BE OVERHEARD BY SPIES. THE WHOLE COUNTRY KNEW ABOUT THE IMPORTANCE OF NOT TALKING ABOUT TROOPS MOVEMENTS. IT WAS ABOUT NATIONAL SECURITY.

CODEBREAKERS KEPT THEIR SECRET FOR DECADES AND COULD NOT SHARE THEIR SUCCESS WITH FAMILY AND FRIENDS.

"It was May 5, late in the evening, and we were working the evening shift... Suddenly the news came through that Italy had given in, and so they immediately gave us 48 hours' leave, because it meant the war (in Europe) was over"

"I just wanted to shout 'the war's over!' and I couldn't"
— JOAN JOSLIN —

IN 1974, THE OFFICIAL REPORTS ABOUT BLETCHLEY PARK APPEARED AND THE WORK OF TURING, GORDON WELCHMAN, ALASTAIR DENNISTON, EDWARD TRAVIS AND HUGH ALEXANDER WERE RELEASED.

TODAY, IT IS WIDELY ACKNOWLEDGED 75% OF THE CODEBREAKERS IN BLETCHLEY PARK WERE WOMEN. THEIR CONTRIBUTION TO BRITAIN'S DECRYPTION UNIT CONTINUES TO RECEIVE RECOGNITION.

AFTER THE WAR MOST OF THE WOMEN CODEBREAKERS WENT BACK TO THEIR LIVES. THEY COULD NOT DISCUSS THEIR WORK.

SADAKO SASAKI

7TH JANUARY 1943, HIROSHIMA, JAPAN — 25TH OCTOBER 1955, HIROSHIMA, JAPAN

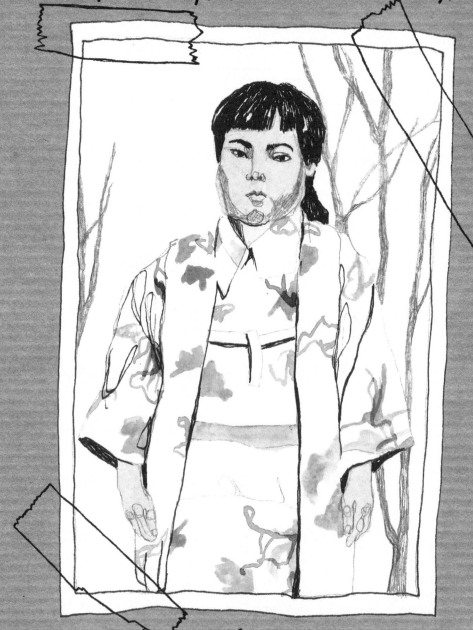

ON AUGUST 6, 1945 THE U.S. DROPPED THE ATOMIC BOMB
ON HIROSHIMA. SADAKO SASAKI WAS AT HOME,
1.6KM AWAY FROM THE PLACE WERE THE BOMB
DETONATED. SASAKI WAS 2 YEARS OLD. 9 YEARS LATER
SADAKO WAS DIAGNOSED WITH LEUKEMIA.
DOCTORS GAVE HER ONE YEAR TO LIVE.

LEUKEMIA CASES INCREASED IN THE YEARS AFTER ATOMIC BOMB DROPPED ON HIROSHIMA. CHILDREN WERE ESPECIALLY VULNERABLE.

WHEN SASAKI WAS IN THE HOSPITAL HER ROOMMATE SHARED A JAPANESE LEGEND.

THE CRANE, A HOLY CREATURE IN ANCIENT JAPAN, AND SYMBOL OF LONGEVITY AND GOOD LUCK (BELIEVED TO LIVE 1000 YEARS) HAS THE POWER TO GRANT A WISH TO A PERSON WHO FOLDS ONE THOUSAND ORIGAMI CRANES.

SASAKI SPENT HER DAYS IN HOSPITAL FOLDING ORIGAMI CRANES. SHE USED MEDICINE WRAPPING, NEWSPAPERS, AND WRAPPING PAPER FROM "GET WELL" GIFTS. SHE EVEN WENT AROUND THE HOSPITAL ASKING OTHER PATIENTS FOR PAPER AND HER BEST FRIEND HELPED HER BRINGING MORE PAPERS FROM THEIR SCHOOL.

SADAKO MADE 644 ORIGAMI CRANES BEFORE SHE DIED FROM LEUKEMIA. WHEN SHE DIED HER CLASSMATES FOLDED 1,000 MORE TO BURY THEM WITH HER.

CHILDREN FROM HER SCHOOL RAISED MONEY TO BUILD A MEMORIAL FOR SADAKO AND THE INNOCENT VICTIMS OF WAR CALLED THE CHILDREN'S PEACE MONUMENT, IN PEACE MEMORIAL PARK, HIROSHIMA. THERE IS A MESSAGE AT THE BOTTOM OF THE MONUMENT WHICH SAYS:

"This is our cry. This is our prayer. Peace in the world."

EVERY YEAR THOUSANDS OF CHILDREN LEAVE THEIR ORIGAMI CRANES IN MEMORY OF CHILD VICTIMS OF WAR.

IT IS ESTIMATED THE HIROSHIMA AND NAGASAKI BOMBS KILLED 270.000 PEOPLE. THIS INCLUDED PEOPLE KILLED INSTANTLY FROM THE DETONATION OF BOTH BOMBS AND DEATHS DUE TO RADIATION-INDUCED CANCER.

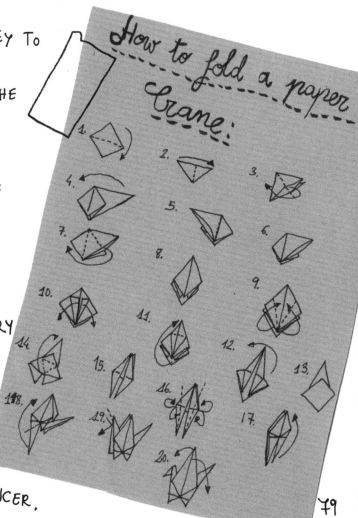

How to fold a paper crane:

1. 2. 3. 4. 5. 6. 7. 8. 9. 10. 11. 12. 13. 14. 15. 16. 17. 18. 19. 20.

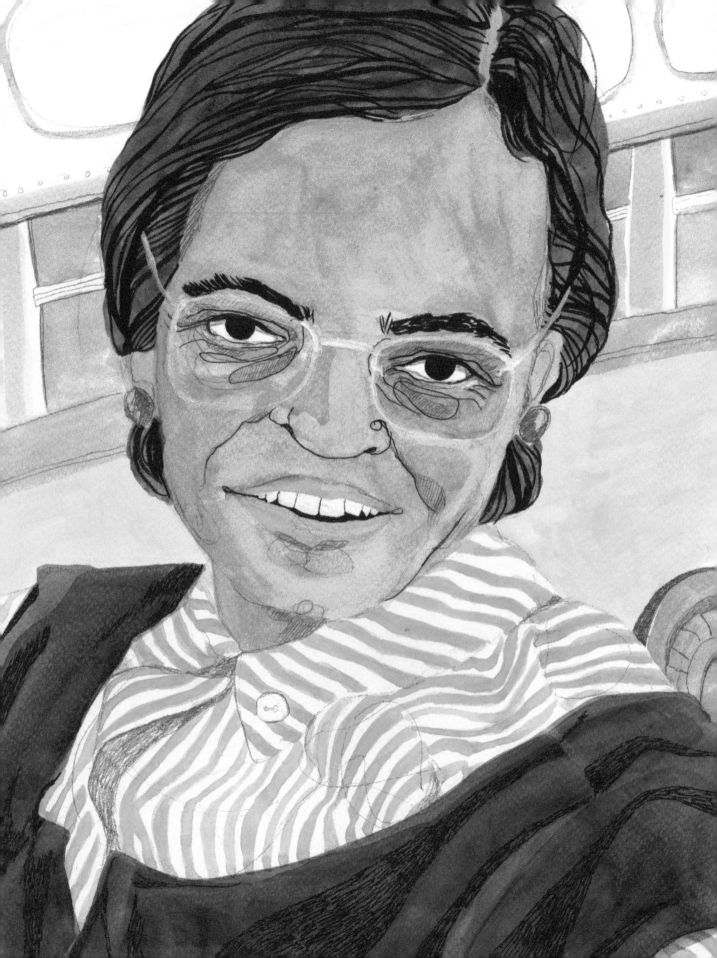

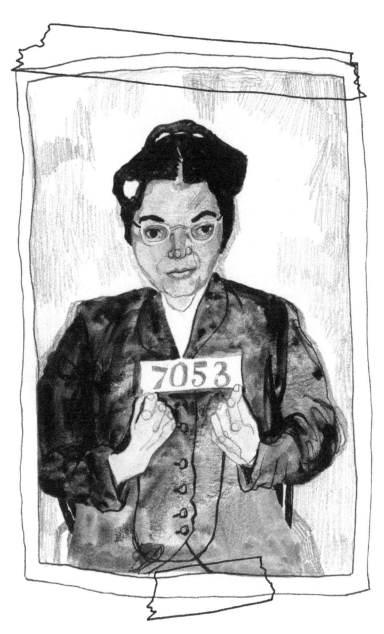

ROSA PARKS

CALLED "THE MOTHER OF THE CIVIL RIGHTS MOVEMENT"

4TH FEBRUARY 1913, TUSKEGEE, ALABAMA —
24TH OCTOBER 2005, DETROIT, MICHIGAN

ROSA PARKS LIVED IN MONTGOMERY, ALABAMA.

THE SOUTHERN UNITED STATES ALABAMA RACIAL SEGREGATION LAWS, SEPARATION OF HUMANS INTO RACIAL OR OTHER ETHNIC GROUPS IN DAILY LIFE, WERE STRICTLY ENFORCED. THESE LAWS APPLIED TO ACTIVITIES SUCH AS EATING IN A RESTAURANT, USING A PUBLIC BATHROOM, ATTENDING SCHOOL, DRINKING FROM A WATER FOUNTAIN, AND RIDING ON A BUS.

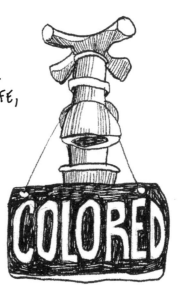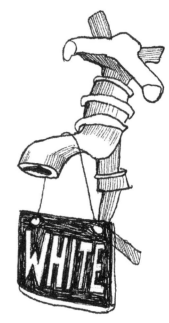

SEGREGATION LAWS AND RIDING ON A BUS

THE TEN FIRST SEATS WERE RESERVED FOR WHITE PEOPLE. EVEN IF THERE WERE NO WHITE PEOPLE ON THE BUS, BLACK PEOPLE HAD TO STAND UP INSTEAD OF USING SEATS DESIGNATED FOR WHITE PEOPLE.

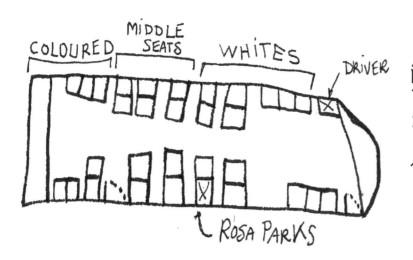

IN 1943 PARKS BOARDED A BUS. THE BUS WAS FULL, SO SHE SAT DOWN IN THE WHITES ONLY DESIGNATED AREA. THE BUS DRIVER KICKED HER OFF THE BUS. SHE PROMISED HERSELF NOT TO TAKE THAT SAME BUS AGAIN.

PARKS DECIDED TO GET INVOLVED WITH HER HUSBAND, RAYMOND PARKS, AND A CIVIL RIGHTS LEADER AND UNION ORGANIZER IN ALABAMA, E.D. NIXON, IN THE FIGHT FOR THE CIVIL RIGHTS.

DURING RACIAL SEGREGATION LAWS THERE WERE WHITE PEOPLE WHO REJECTED THE MISTREATMENT OF BLACK PEOPLE. VIRGINIA DURR, A WHITE AND VERY CLOSE FRIEND OF PARKS, SPONSORED THE HIGHLANDER FOLK SCHOOL, A PLACE WHERE WHITE AND BLACK PEOPLE SHARED A SAFE NON-VIOLENT ENVIRONMENT.

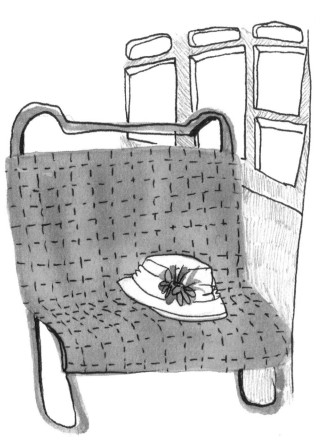

IT WOULD BE HERE WHERE PETE SEEGER POPULARIZED THE GOSPEL SONG "WE SHALL OVERCOME," WHICH BECAME A PROTEST SONG AND A KEY ANTHEM OF THE CIVIL RIGHTS MOVEMENT.

DECEMBER 1, 1955, MONTGOMERY, ALABAMA

ON THE 1ST OF DECEMBER 1955 ROSA GOT ON A BUS NOT NOTICING THAT THE DRIVER WAS JAMES F. BLAKE, THE SAME DRIVER WHO 12 YEARS PRIOR KICKED HER OFF THE BUS.

PARKS SAT IN THE FIRST ROW RESERVED FOR BLACK PEOPLE. AFTER A WHILE, A WHITE PASSENGER GOT ON THE BUS. THERE WERE NO SEATS FOR HIM. THE DRIVER DEMANDED BLACKS FROM THE FIRST ROW DESIGNATED FOR BLACK PEOPLE LEAVE THEIR SEATS FOR THE WHITE MAN. ROSA REFUSED. THE DRIVER CALLED THE POLICE AND ROSA WAS ARRESTED.

NEWS SPREAD THROUGH THE CITY. WHEN E.D. NIXON FOUND OUT THAT PARKS WAS IN JAIL HE WENT TO VIRGINIA DURR'S HOUSE TO ASK FOR HELP. TOGETHER, THEY GOT ROSA OUT FROM JAIL. THAT DAY NIXON MADE A DECISION.

ENOUGH IS ENOUGH!

MONTGOMERY BUS BOYCOTT

PAMPHLETS WERE DISTRIBUTED ALL OVER THE CITY.

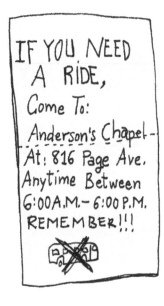

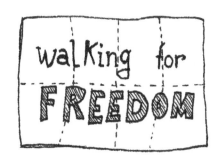

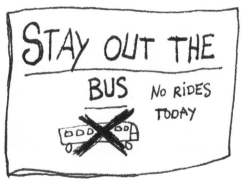

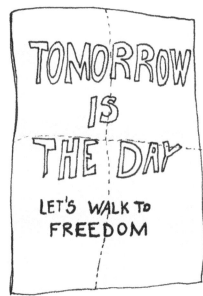

PARKS' TRIAL LASTED LESS THAN 30 MINUTES. SHE WAS FOUND GUILTY.

THAT SAME DAY, MARTIN LUTHER KING JR (MLK) ASKED A CROWD OF 5,000 PEOPLE TO KEEP THE BOYCOTT GOING. OF COURSE, IT SHOULD!

BLACK PEOPLE KEPT GOING TO WORK BY WALKING AND DRIVING. WHOEVER HAD A CAR WOULD HELP. AS A RESULT, THE BUS SYSTEM BUSINESS COLLAPSED.

AFTER A FEW WEEKS OF NON-VIOLENT PROTEST, THE RACE RELATIONS BECAME MORE HOSTILE.
THE KU KLUX KLAN STARTED THREATENED TO KILL BLACKS, THEY BOMBED BLACK CHURCHES AND EVEN E.D. NIXON AND MLK'S HOMES.

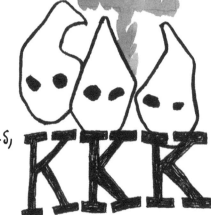

ON THE 20TH OF DECEMBER 1956 MONTGOMERY BUSES WERE DESEGREGATED.
AFTER 381 DAYS WALKING UNDER THE RAIN, WIND, STORMS AND SUFFOCATING SUN,
BLACK PEOPLE FROM MONTGOMERY ACHIEVED THEIR VICTORY.

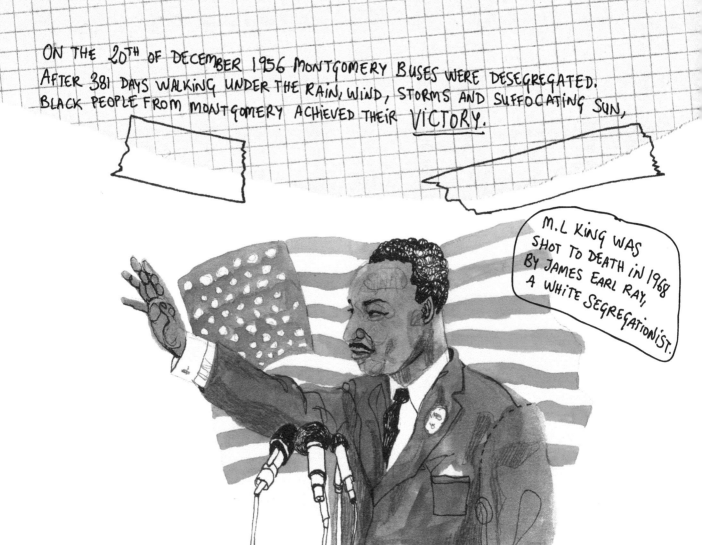

M.L KING WAS SHOT TO DEATH IN 1968 BY JAMES EARL RAY, A WHITE SEGREGATIONIST.

"Our aim must never be to defeat or humiliate the white
man, but to win his friendship and understanding.
We must come to see that the end we seek is a society at peace
with itself, a society that can live with its conscience.
And that will be a day not of the white man, not of the black man.
That will be the day of man as man."
 —PUBLIC SPEECH DELIVERED BY
 M.L. KING ON THE SELMA TO MONTGOMERY
 MARCH IN 1965.—

VALENTINA
TERESHKOVA

Валенти́на Влади́мировна Терешко́ва

6TH MARCH 1937, MÁSLENNIKOVO, YAROSLAV OBLAST,
RUSSIAN SFSR, SOVIET UNION

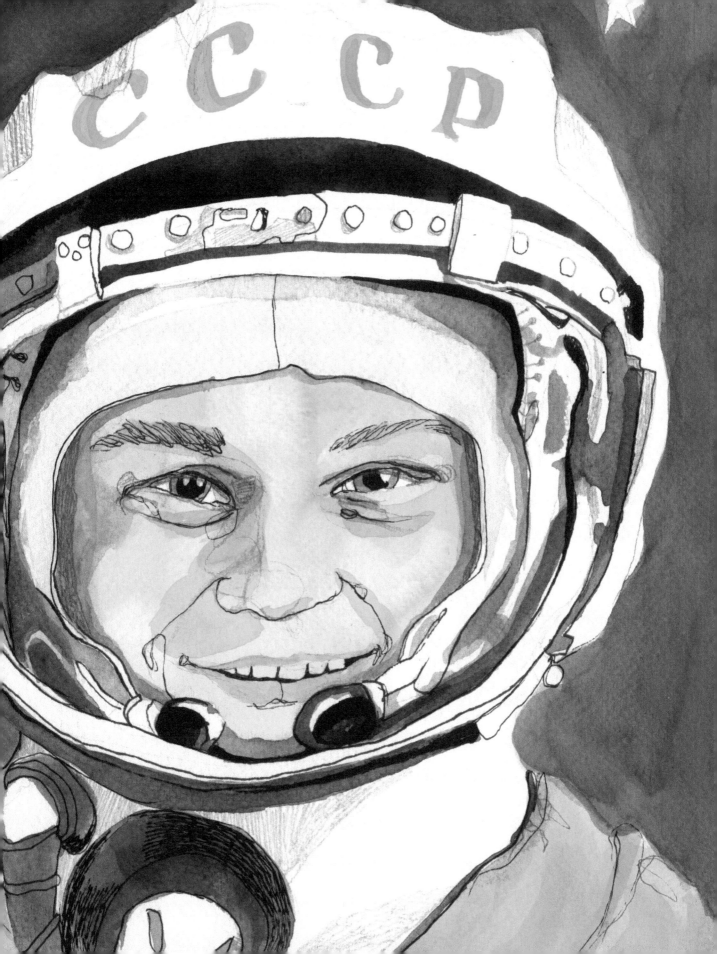

RUSSIAN COSMONAUT, ENGINEER, AND POLITICIAN VALENTINA TERESHKOVA WAS THE FIRST WOMAN TO TRAVEL INTO SPACE.

TERESHKOVA COMPLETED 48 ORBITS IN 2 DAYS, 22 HOURS AND 50 MINUTES IN THE VOSTOK 6, THE LAST SPACECRAFT OF THE VOSTOK PROGRAM.

TERESHKOVA'S DREAM AS A KID WAS TO BECOME A TRAIN DRIVER SO SHE COULD TRAVEL. SHE GREW UP GOING TO SCHOOL AND WORKING IN A TIRE FACTORY AND IN A TEXTILE PLANT. ON HER WAY TO WORK EACH MORNING TERESHKOVA WALKED ALONG THE RIVER. SHE COULD SEE PARACHUTISTS TRAINING. SHE DECIDED SHE WANTED TO ENROL IN THE LOCAL AEROCLUB TO LEARN SKY DIVING. ON THE 21ST OF MAY 1959, AT AGE OF 22, TERESHKOVA MADE HER FIRST SKYDIVING JUMP.

THE SPACE RACE WAS A 20TH CENTURY COMPETITION BETWEEN TWO COLD WAR RIVALS, THE SOVIET UNION AND THE UNITED STATES, FOR SUPREMACY IN SPACEFLIGHT CAPABILITY. THE SOVIET UNION, AFTER LAUNCHING THE FIRST MANNED SPACEFLIGHT AND THE FIRST HUMAN INTO SPACE IN HISTORY, ALSO WANTED TO BE THE FIRST PUTTING A FEMALE IN SPACE. LAUNCHING A WOMAN WAS REPORTEDLY KOROLEV'S IDEA.

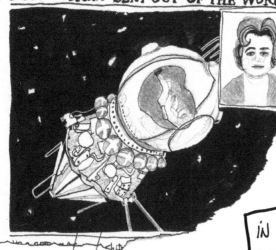

FIRST WOMAN SENT OUT OF THE WORLD

Soviet Orbit

TERESHKOVA WAS ONE OF A SMALL CORPS OF FEMALE COSMONAUTS WHO WERE AMATEUR PARACHUTISTS, BUT SHE WAS THE ONLY ONE TO FLY INTO SPACE ON VOSTOK 6.

IN 1962 TERESHKOVA JOINED THE FEMALE COSMONAUT CORPS AS A VOLUNTARY CANDIDATE. THESE WERE THE REQUIREMENTS:
- UNDER THE AGE OF 30
- UNDER 70 KG.
- UNDER 1.70 M.
- THE RIGHT POLITICAL IDEOLOGICALLY
- NO LESS THAN 200 HOURS OF AIRPLANE FLIGHT OR 50 PARACHUTE JUMPS.

TERESHKOVA HAD 90 JUMPS

EVERYTHING RELATED TO SPACE EXPLORATION WAS KEPT A SECRET. TERESHKOVA WASN'T ALLOWED TO TALK ABOUT HER WORK OR TRAINING. SO SHE MADE A STORY UP FOR HER MUM SAYING THAT SHE HAD TO TRAVEL TO MOSCOW AS A RESERVE OF THE SOVIET SELECTION OF PARACHUTISTS. HER FAMILY DISCOVERED ON THE RADIO SHE WAS THE FIRST WOMAN (ALSO THE FIRST CIVILIAN) INTO SPACE.

VOSTOK PROGRAMME

THE PROJECT CONSISTED OF 6 MISIONS IN BETWEEN APRIL 1961 AND JUNE 1963. VOSTOK 1 CARRIED THE FIRST HUMAN INTO SPACE, YURI GAGARIN.

VOSTOK 6 WAS A JOINT FLIGHT WITH ANOTHER SPACECRAFT, VOSTOK 5.

THIS MISSION WAS PART OF A BIOMEDICAL AND SCIENTIFIC EXPERIMENT TO ANALYSE IF WOMEN AND MEN EXPERIENCED THE SAME PHYSICAL AND MENTAL RESISTANCE DURING SPACE FLIGHT.

"Hey sky! Take off your hat, I'm on my way!"

TERESHKOVA WAS 26 YEARS OLD AND SHE LAUNCHED INTO SPACE ON THE 16TH OF JUNE 1963 FROM BAIKONUR COSMODROME. HER CALL SIGN IN THIS MISSION WAS CHAIKA (Чáйка) WHICH MEANT SEAGULL.

THIS WAS THE ONLY TIME TERESHKOVA TRAVELLED TO SPACE.

IN 1969, SHE GRADUATED WITH DISTINCTION AT THE ZHUKOVSKY MILITARY AIR ACADEMY AND IN 1977 EARNED A DOCTORATE IN ENGINEERING. TERESHKOVA ALSO CARRIED OUT POLITICAL TASKS FOR THE SOVIET UNION.

ASTEROID 1671 CHAIKA, DISCOVERED IN 1934, WAS NAMED IN HER HONOR.

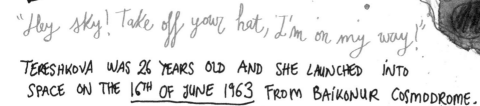

IT TOOK 19 YEARS TO SEND THE SECOND WOMAN INTO SPACE. HER NAME WAS SVETLANA SAVITSKAYA. SHE WAS THE FIRST WOMAN TO SPACEWALK.

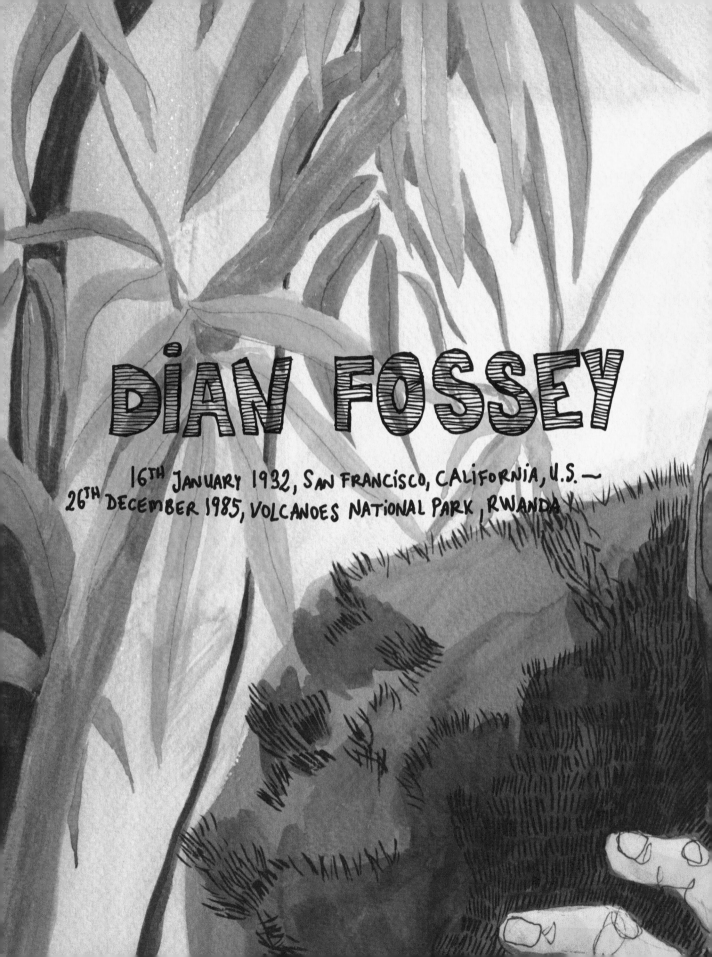

DIAN FOSSEY

16TH JANUARY 1932, SAN FRANCISCO, CALIFORNIA, U.S. —
26TH DECEMBER 1985, VOLCANOES NATIONAL PARK, RWANDA

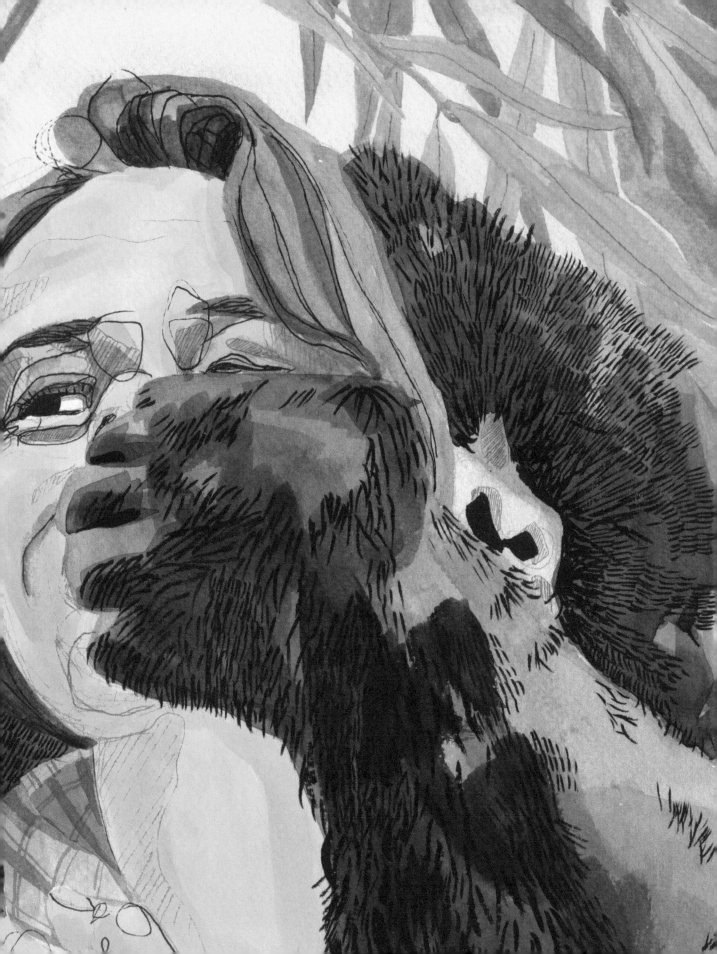

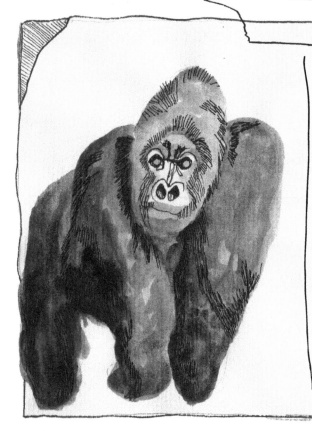

GORILLA BERINGEI BERINGEI

THE MOUNTAIN GORILLA IS ONE OF THE TWO SUBSPECIES OF THE EASTERN GORILLA.

ADULT MALES REACH 5FT 7in (1.7m) IN HEIGHT WHEN STANDING AND WEIGH 340 POUNDS (155KG)

GORILLAS LIVE IN MISTY AND COLD FORESTS CLOSE TO EXTINCT VOLCANOS AT RWANDA, UGANDA AND DEMOCRATIC REPUBLIC OF CONGO. THEY ARE CRITICALLY ENDANGERED ANIMALS. THEY ARE THREATENED BY HUNTING, DEFORESTATION, HABITAT LOSS, AND POACHING. THERE ARE LESS THAN 900 INDIVIDUALS REMAINING IN THE WILD AND NONE IN ZOOS.

DIAN FOSSEY DEDICATED HER LIFE TO STUDYING THESE PRIMATES. IN 1963 FOSSEY'S QUIT HER HOSPITAL JOB AND TRAVELLED TO THE REPUBLIC OF THE CONGO (TODAY THE DEMOCRATIC REPUBLIC OF THE CONGO) TO STUDY GORILLAS.

HER RESEARCH ON GORILLAS WAS SUPPORTED BY THE NATIONAL GEOGRAPHIC SOCIETY AND WILKIE FOUNDATION.

DUE TO POLITICAL UPHEAVAL AND CONFLICT IN REPUBLIC OF THE CONGO FOSSEY MOVED TO RWANDA TO CONTINUE HER RESEARCH. SHE FOUNDED THE KARISOKE RESEARCH CENTER IN RUHENGERI.

AT THE BEGINNING OF HER RESEARCH IT WAS VERY HARD FOR FOSSEY TO GET CLOSE TO THE GORILLAS. SHE DEDICATED HERSELF TO HER RESEARCH. HER PATIENT RESEARCH METHODS ALLOWED HER TO UNDERSTAND THE BEHAVIOR OF THE MOUNTAIN GORILLAS. SHE FINALLY GAINED THEIR ACCEPTANCE.

SPECIAL SUPPLEMENT: WALL MAP OF THE WEST INDIES AND CENTRAL AMERICA

NATIONAL GEOGRAPHIC

OFFICIAL JOURNAL OF THE NATIONAL GEOGRAPHIC SOCIETY WASHINGTON, D.C.

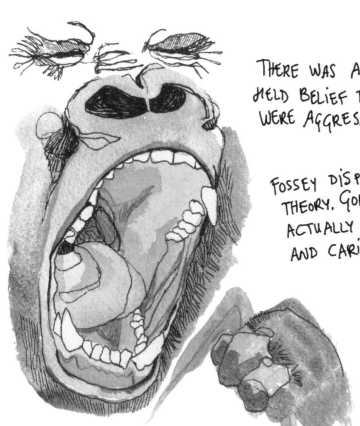

THERE WAS A COMMONLY HELD BELIEF THAT GORILLAS WERE AGGRESSIVE ANIMALS.

FOSSEY DISPROVED THIS THEORY. GORILLAS ARE ACTUALLY COMPASSIONATE AND CARING ANIMALS.

LIKE HUMANS, GORILLAS HAVE DIFFERENT FACIAL FEATURES THAT CHARACTERIZE EACH INDIVIDUAL GORILLA.

FOSSEY WAS CONSIDERED A THREAT TO SEVERAL GROUPS OF PEOPLE.

SHE FOUGHT AGAINST POACHING. SHE DESTROYED THE TRAPS SET BY POACHERS AND ADVOCATED TO STOP THE KILLING AND ILLEGAL TRAFFICKING OF GORILLAS.

ON THE 26TH OF DECEMBER 1985 FOSSEY WAS MURDERED IN HER BEDROOM WITH A MACHETE. HER MURDER IS STILL AN OPEN CASE.

FOSSEY'S COURAGE MADE THE WORLD THINK ABOUT THE NEED OF FOR NATURAL HABITAT CONVERSATION AND FOR THE PRESERVATION OF THE GORILLAS.

HER STUDIES ARE STILL VALID AND ALMOST EVERYTHING WE KNOW ABOUT MOUNTAIN GORILLAS IS BASED ON HER RESEARCH.

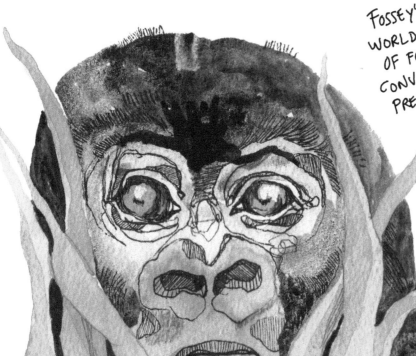

93

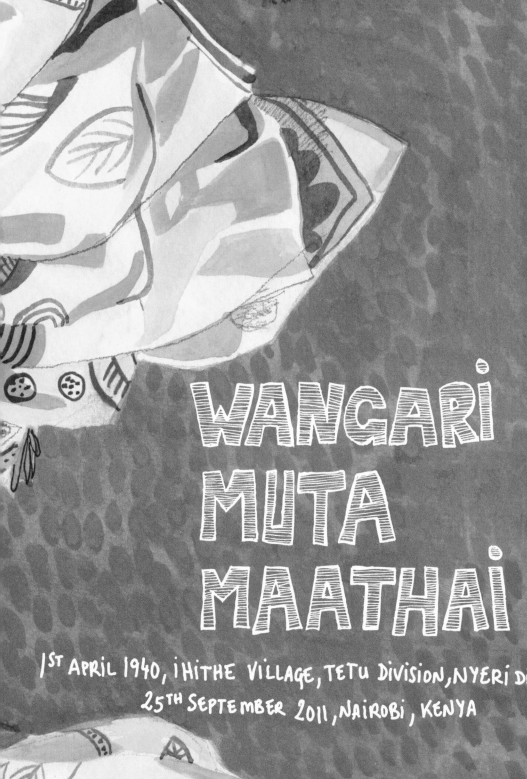

WANGARI MUTA MAATHAI

A BRITISH COLONY BY THAT TIME

1ST APRIL 1940, IHITHE VILLAGE, TETU DIVISION, NYERI DISTRICT, KENYA—
25TH SEPTEMBER 2011, NAIROBI, KENYA

WANGARI MUTA MAATHAI WAS AN INTERNATIONALLY RENOWNED KENYAN ENVIRONMENTAL POLITICAL ACTIVIST AND NOBEL LAUREATE.

MAATHAI WAS ONE OUT OF 300 KENYAN STUDENTS SELECTED TO STUDY IN THE USA. IN 1966, SHE EARNED HER MASTER'S DEGREE IN BIOLOGICAL SCIENCES.
IN 1971 MAATHAI EARNED HER DOCTORATE IN VETERINARY ANATOMY BY THE UNIVERSITY OF NAIROBI. FIVE YEARS LATER MAATHAI WAS DESIGNATED CHAIR OF THIS DEPARTMENT.

GREEN BELT MOVEMENT

MAATHAI WAS CONCERNED ABOUT THE EXTREME POVERTY THAT AFFECTED THOUSANDS OF KENYANS. SHE OBSERVED THAT MANY OF THE PROBLEMS WERE DUE TO ENVIRONMENTAL DEGRADATION.
IN 1976, MAATHAI CALLED ON WOMEN:

"Women are responsible for their children, they cannot sit back, waste time and see them starve"

OBJETIVE: PLANTING TREES AS A RESOURCE TO IMPROVE THE LIVING CONDITIONS OF THE POPULATION.

THE PROGRAM WAS PREDOMINANTLY CARRIED OUT BY WOMEN. THEY HARVESTED SEEDS IN NEARBY FORESTS AND CREATED TREE NURSERIES THROUGHOUT THE COUNTRY FOR FEES WITH THE GOAL OF MOVING THESE TREES TO THE FOREST. TEN YEARS LATER THE MOVEMENT HAD SPREAD TO OTHER AFRICAN COUNTRIES. BY 2004 THERE WERE 3,000 NURSERIES MANAGED BY 35,000 WOMEN. IT IS ONE OF THE MOST SUCCESSFUL COMMUNITY DEVELOPMENT AND ENVIRONMENTAL PROTECTION PROJECTS TO DATE.

MATHAI + A ⟹ MAATHAI

IN 1979 MAATHAI GOT DIVORCED. HER HUSBAND, MWANGI MATHAI, ALLEGED THAT SHE WAS "TOO STRONG-MINDED FOR A WOMAN" MAKING HIM "UNABLE TO CONTROL HER". HE EVEN ACCUSED HER OF ADULTERY.
THE JUDGE RULED IN MWANGI MATHAI'S FAVOUR. MAATHAI RESPONDED TO THIS DECISION BY STATING THE JUDGE WAS CORRUPT AND INCOMPETENT. SHE WAS SENTENCED TO SIX MONTHS PRISON FOR CONTEMPT OF COURT. BUT SPENT ONLY 3 DAYS IN JAIL.
MAATHAI'S HUSBAND DEMANDED HER TO DROP HIS SURNAME, SO SHE ADDED AN A. MATHAI TO MAATHAI.

"Until you dig a hole, you plant a tree, you water it and make it survive, you haven't done a thing. You are just talking".

POLITICAL ACTIVIST

MAATHAI FOUGHT FOR <u>HUMAN RIGHTS</u>, <u>DEMOCRACY</u>, AND <u>AGAINST CORRUPTION</u> IN KENYA. SHE WAS SENT TO PRISON MANY TIMES.
MAATHAI WAS ALSO A FIERCE OPPONENT TO THE DICTATORIAL REGIME OF DANIEL ARAP MOI.
AFTER THE ESTABLISHMENT OF DEMOCRACY, MAATHAI CAMPAIGNED FOR <u>PARLIAMENT</u> WINNING WITH 98% OF THE VOTE IN 2002.
IN 2003, MAATHAI BECAME ASSISTANT MINISTER IN THE MINISTRY FOR ENVIRONMENT AND NATURAL RESOURCES.

NOBEL PEACE PRIZE

MAATHAI'S CONTRIBUTION TO SUSTAINABLE DEVELOPMENT, DEMOCRACY, AND PEACE WAS RECOGNIZED WITH THE NOBEL PEACE PRIZE IN <u>2004</u>. SHE WAS THE FIRST <u>AFRICAN WOMAN</u> AND THE <u>FIRST</u> <u>ENVIRONMENTALIST</u> TO WIN THE NOBEL PEACE PRIZE.

NOBEL WOMEN'S INICIATIVE

CREATED TO SUPPORT THE WORK DONE FOR WOMEN'S RIGHTS AROUND THE WORLD.
FOUNDERS:

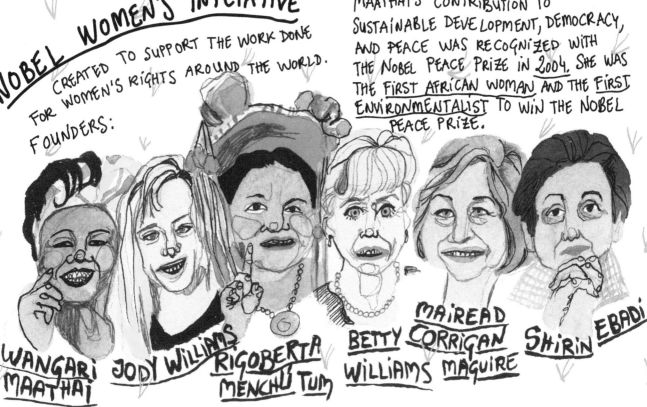

<u>WANGARI MAATHAI</u> <u>JODY WILLIAMS</u> <u>RIGOBERTA MENCHU TUM</u> <u>BETTY WILLIAMS</u> <u>MAIREAD CORRIGAN MAGUIRE</u> <u>SHIRIN EBADI</u>

IN 2011, MAATHAI PASSED AWAY IN NAIROBI DUE TO OVARIAN CANCER AT THE AGE OF 71.
BY THEN, THE GREEN BELT MOVEMENT HAD PLANTED BETWEEN 20 AND 30 MILLION TREES IN AFRICA.
"MAMA MITI", AS SHE WAS KNOWN, LEFT A <u>MUCH BETTER WORLD</u> FOR ALL PEOPLE.
└ (THE MOTHER OF TREES)

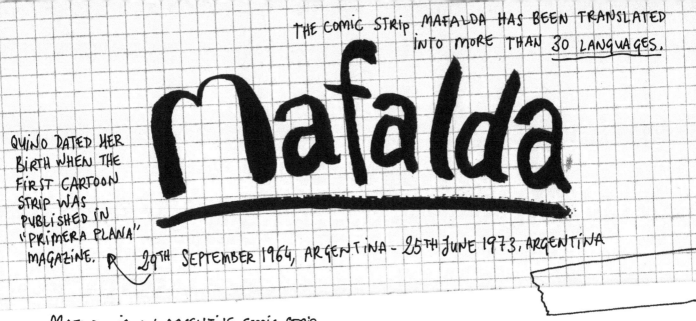

THE COMIC STRIP MAFALDA HAS BEEN TRANSLATED INTO MORE THAN 30 LANGUAGES.

Mafalda

QUINO DATED HER BIRTH WHEN THE FIRST CARTOON STRIP WAS PUBLISHED IN "PRIMERA PLANA" MAGAZINE. 29TH SEPTEMBER 1964, ARGENTINA - 25TH JUNE 1973, ARGENTINA

MAFALDA IS AN ARGENTINE COMIC STRIP WRITTEN AND DRAWN BY CARTOONIST JOAQUÍN SALVADOR LAVADO, BETTER KNOWN BY HIS PEN NAME QUINO.

THE COMIC STRIPS RAN FROM 1964 TO 1973.

IN 1965 THE COMIC STRIP MAFALDA APPEARED IN THE INFLUENTIAL NEWSPAPER "EL MUNDO", AFTER "EL MUNDO" CLOSED, IT APPEARED IN "SIETE DÍAS" MAGAZINE.

- Comic Strip CHARACTER: MAFALDA
- GENDER: YOUNG GIRL
- AGE: 6
- ADRESS: CALLE CHILE 371 SAN TELMO. BUENOS AIRES
- PERSONALITY: INQUISITIVE, GENEROUS, GRUMPY

WHEN SHE GROWS UP SHE WANTS TO WORK AS AN INTERPRETER IN THE UNITED NATIONS TO CONTRIBUTE TO THE WORLD PEACE.

MAFALDA WAS THE OLDEST CHILD IN A MIDDLE-CLASS FAMILY. MAFALDA'S MOTHER, RAQUEL, WAS A HOUSEWIFE. HER FATHER (WE DON'T KOW HIS NAME), WORKED IN AN OFFICE. THEY WERE CONSTANTLY BOMBARDED WITH QUESTIONS FROM MAFALDA.

MAFALDA WAS A REFLECTION OF THE LATINO AMERICAN PROGRESSIVE YOUTH. SHE WAS CONCERNED ABOUT ISSUES OF EQUALITY, FEMINISM AND WORLD PEACE. WHILE SHE BELIEVED WE COULD MAKE A BETTER WORLD, SHE THOUGHT HUMAN BEINGS WERE THE BIGGEST THREAT TO PLANET EARTH.

INQUISITIVE, FUNNY, AND NAÏVE, SHE MADE US THINK ABOUT HUMANITY.
(ALTHOUGH WE DISCOVERED SHE WAS NOT THAT NAÏVE)

LOVE

- PLAYING COWBOYS WITH HER FRIENDS.

WOODY WOODPECKER

PEACE

- HUMAN RIGHTS

- DEMOCRACY

PANCAKES

HATE

- RACISM

SOUP

- WAR

- NUCLEAR WEAPON

QUINO <u>STOPPED</u> DRAWING MAFALDA'S COMIC STRIPS IN 1973. AFTER THE 1973 CHILEAN COUP D'ETAT BECAME BLOODY QUINO WOULD STATE IT WAS IMPOSSIBLE TO MAKE MAFALDA OMIT HER OPINION ABOUT WHAT WAS HAPPENING IN CHILE. HE KNEW IF HE KEPT PUBLISHING MAFALDA HE WOULD HAVE TO LEAVE ARGENTINA OR HE WOULD GET SHOT.

IN 1976, QUINO REPRODUCED MAFALDA'S CHARACTERS FOR THE CONVENTION ON THE RIGHTS OF THE CHILD OF UNICEF.

IN 2009 MAFALDA APPEARED IN THE ITALIAN NEWSPAPER "LA REPUBBLICA" TO CRITICIZE MISOGYNISTIC STATEMENTS MADE BY SILVIO BERLUSCONI, THE ITALIAN PRIME MINISTER.

MAFALDA WOULD APPEAR OCCASIONALLY IN CAMPAIGNS RELATED TO <u>CHILDREN'S RIGHTS</u>, <u>EDUCATION</u>, AND <u>DEMOCRACY</u>.

MAFALDA'S FRIENDS

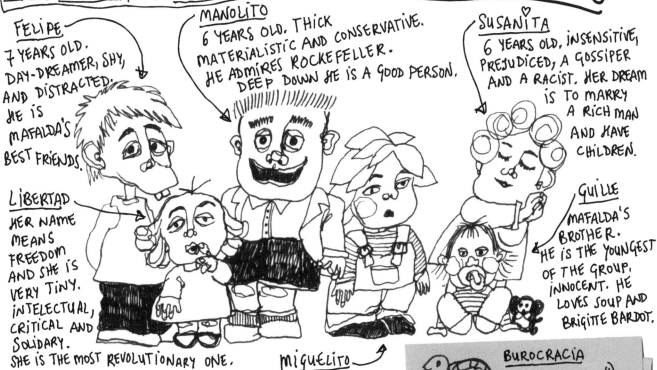

FELIPE
7 YEARS OLD. DAY-DREAMER, SHY, AND DISTRACTED. HE IS MAFALDA'S BEST FRIENDS.

MANOLITO
6 YEARS OLD. THICK MATERIALISTIC AND CONSERVATIVE. HE ADMIRES ROCKEFELLER. DEEP DOWN HE IS A GOOD PERSON.

SUSANITA
6 YEARS OLD. INSENSITIVE, PREJUDICED, A GOSSIPER AND A RACIST. HER DREAM IS TO MARRY A RICH MAN AND HAVE CHILDREN.

GUILLE
MAFALDA'S BROTHER. HE IS THE YOUNGEST OF THE GROUP, INNOCENT. HE LOVES SOUP AND BRIGITTE BARDOT.

LIBERTAD
HER NAME MEANS FREEDOM AND SHE IS VERY TINY. INTELECTUAL, CRITICAL AND SOLIDARY. SHE IS THE MOST REVOLUTIONARY ONE.

MIGUELITO
5 YEARS OLD. VERY NAÏVE. HE ALWAYS THINKS ABOUT TRIVIAL MATTERS.

BUROCRACIA ("BUREAUCRACY") IT IS MAFALDA'S PET. IT IS A VERY SLOW TURTLE.

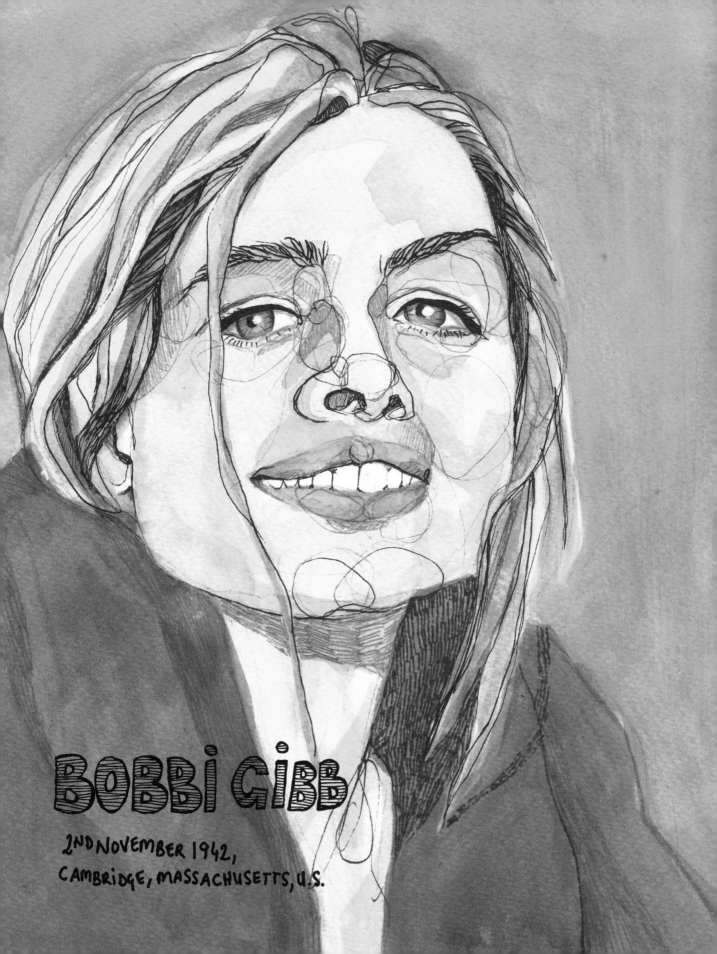

BOBBI GIBB

2ND NOVEMBER 1942,
CAMBRIDGE, MASSACHUSETTS, U.S.

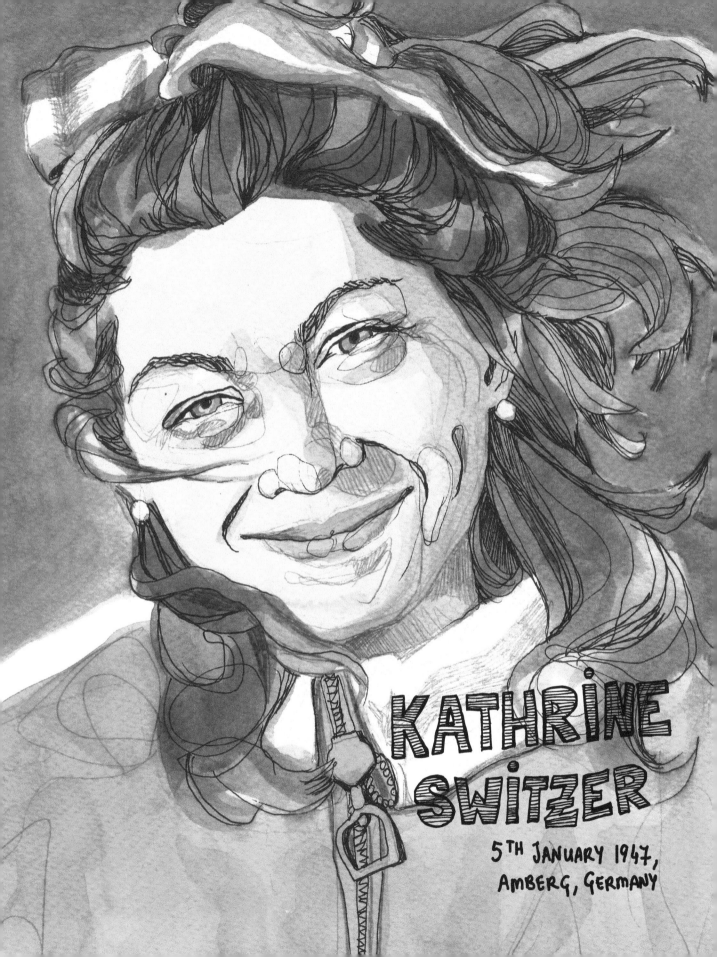

KATHRINE SWITZER

5TH JANUARY 1947,
AMBERG, GERMANY

ROBERTA LOUISE "BOBBI" GIBB IS THE FIRST WOMAN TO RUN THE ENTIRE BOSTON MARATHON (1966).
TODAY IT IS COMMON TO SEE WOMEN RUNNING IN MARATHONS, BUT NOT LONG AGO THIS WAS INCONCEIVABLE.

'60s U.S

WOMEN COULD NOT COMPETE IN OFFICIAL RACES OF OVER ONE AND ONE-HALF MILES. THEY WERE FORBIDDEN FROM RUNNING MARATHONS. LONG-DISTANCE RUNNING WAS CONSIDERED TOO STRENUOUS AND TOO DANGEROUS FOR THEM. PEOPLE BELIEVED WOMEN WEREN'T ABLE TO PHYSICALLY ENDURE THE STRESS OF RUNNING 26.2 MILES.
PEOPLE BELIEVED THEY COULD DIE.

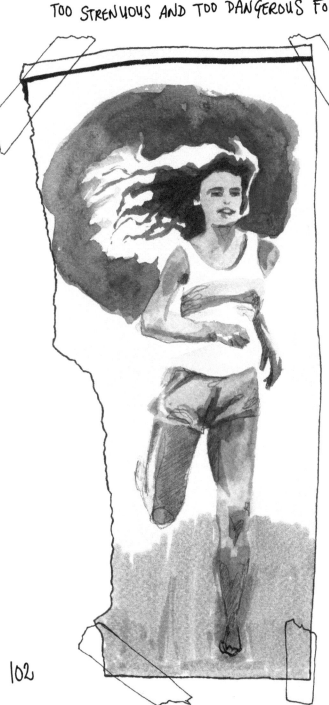

"Women are not physically capable of running a marathon"

THIS WAS THE NOTE THAT GIBB RECEIVED AS A REPLY FOR HER RACE ENTRY IN THE BOSTON MARATHON IN 1966.

WHAT DID GIBB DO?

ON THE DAY OF THE BOSTON MARATHON, GIBB HID BEHIND A BUSH AT THE START OF THE RACE. WHEN THE COMPETITION STARTED, SHE RAN IN AN UNOFFICIAL TIME OF 3.21.25. GIBB WAS THE FIRST WOMEN TO COMPLETE THE MARATHON.

"I was running against the distance, not the men, and I was measuring my potential"

KATHRINE SWITZER IS AN AMERICAN MARATHON RUNNER, AUTHOR, AND TELEVISION COMMENTATOR.

IN 1967, SHE BECAME THE FIRST WOMAN TO RUN THE BOSTON MARATHON AS A NUMBERED ENTRY. THIS WAS ONE YEAR AFTER ROBERTA LOUISE "BOBBI" GIBB BECAME THE FIRST WOMAN TO HAVE RUN THE ENTIRE BOSTON MARATHON IN 1966. SWITZER WAS ASSIGNED NUMBER 261. SHE WAS 20 YEARS OLD AND RAN WITH HER TEAMMATES FROM SYRACUSE UNIVERSITY.

THE OFFICIALS DIDN'T REALIZE RUNNER NUMBER 261 WAS A WOMAN UNTIL THE BOSTON MARATHON STARTED. THE BOSTON MARATHON RACE DIRECTOR WILL CLONEY AND RACE OFFICIAL JOCK SEMPLE TRIED TO STOP SWITZER (OR AT LEAST TO REMOVE HER NUMBER), BUT SWITZER'S BOYFRIEND AND OTHER RUNNERS BLOCKED BOTH CLONEY AND SEMPLE FROM INTERRUPTING SWITZER'S MARATHON RUN.

SWITZER FINALLY REACHED THE FINISH LINE AFTER 4 HOURS AND 20 MINUTES. SHE DIDN'T FINISH BEFORE THE OFFICIAL RACE TIMER STOPPED BUT SHE ACHIVED SOMETHING MUCH MORE IMPORTANT FOR WOMEN AND SOCIETY. FIVE YEARS LATER, IN 1972, WOMEN COULD COMPETE OFFICIALLY IN THE BOSTON MARATHON.

GIBB ALSO RAN IN THE 1967 MARATHON WITHOUT A NUMBER. HER TIME WAS 2:27:17.
IN 1996, ON THE EVENT'S CENTENNIAL OF THE BOSTON MARATHON GIBB WAS OFFICIALLY RECOGNIZED FOR HER THREE WINS IN 1966, 1967 AND 1968.
SWITZER WON THE WOMEN'S 1974 NY CITY MARATHON AND RAN HER PERSONAL BEST TIME, 2:51:37, AT THE 1975 BOSTON MARATHON.

"Get the hell out of my race and give me those numbers."

PHOTOGRAPHS CAPTURING THE MOMENT WHEN BOTH CLONEY AND SEMPLE TRIED TO GRAB SWITZER DURING THE RACE WERE PRINTED IN NATIONAL AND INTERNATIONAL NEWSPAPERS THE DAY AFTER THE BOSTON MARATHON. BOTH CLONEY AND SEMPLE EXPLAINED THEY WERE FOLLOWING THE RULES.
YEARS LATER, IN 1973, SWITZER AND SEMPLE MADE PEACE PUBLICLY IN 1973.

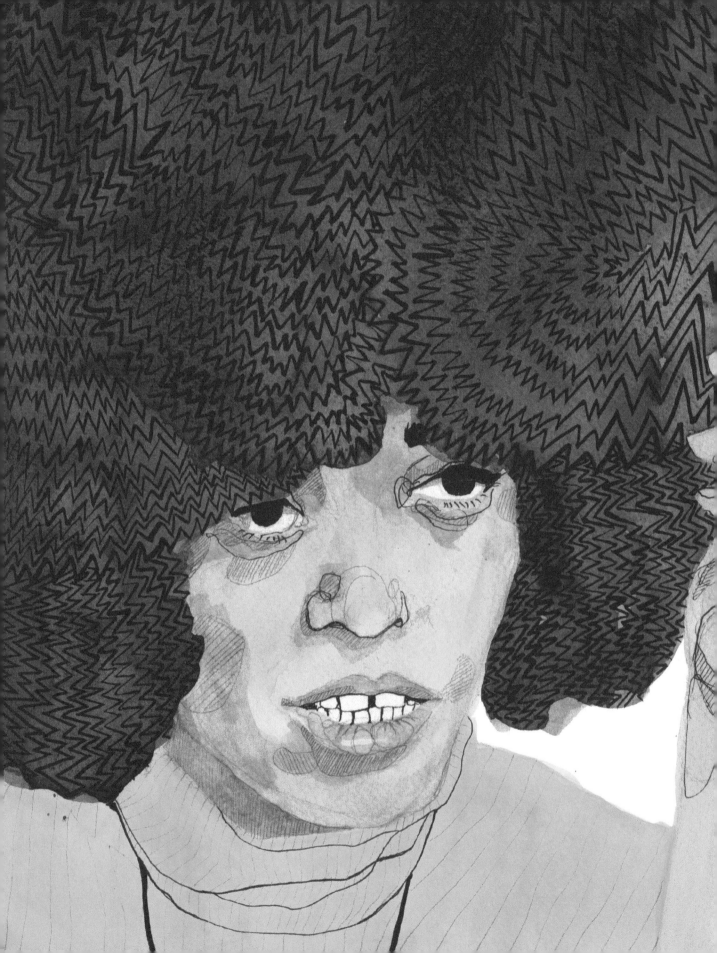

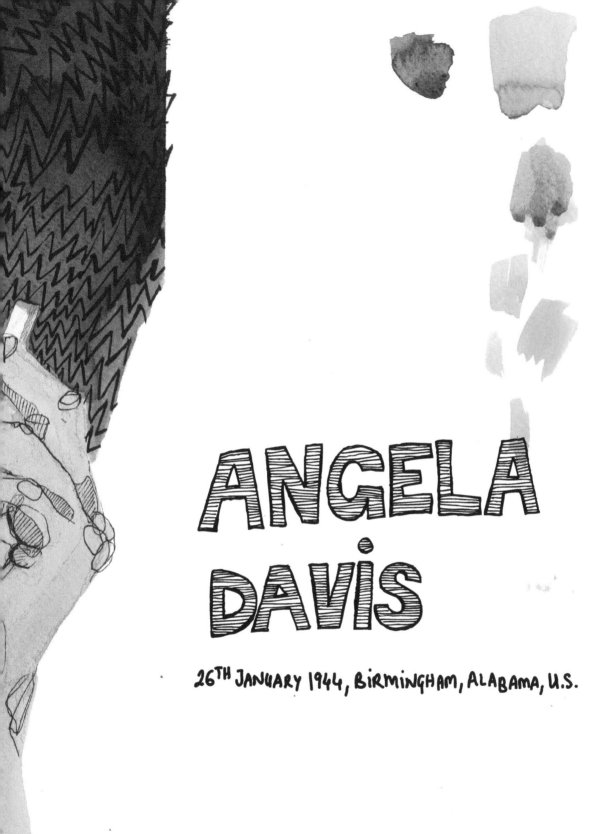

ANGELA DAVIS

26TH JANUARY 1944, BIRMINGHAM, ALABAMA, U.S.

ANGELA DAVIS IS AN AMERICAN POLITICAL ACTIVIST, ACADEMIC, AN AUTHOR.

DAVIS WAS BORN IN BIRMINGHAM, ALABAMA. HER FAMILY LIVED IN THE "DYNAMITE HILL" NEIGHBORHOOD, WHICH WAS MARKED IN THE 1950s BY THE BOMBINGS OF HOUSES OF MIDDLE-CLASS BLACKS.
WHEN DAVIS WAS 14 SHE WENT TO A SCHOOL IN NEW YORK CITY TO ATTEND A PROGRAM WHICH HELPED BLACK STUDENTS FROM THE SOUTH GO TO INTEGRATED SCHOOLS IN THE NORTH.

IN THE 1960s DAVIS WAS A PROMINENT COUNTERCULTURE ACTIVIST AND RADICAL.

SHE FOLLOWED THE COMMUNIST AND SOCIALIST POLITICAL IDEOLOGY.
DAVIS WAS A BRILLIANT STUDENT. HER CAREER BROUGHT HER TO FRANCE AND GERMANY, WHERE SHE WOULD TAKE PART ACTIVELY IN PROTESTS AGAINST VIETNAM WAR.

END the WAR in GET OUT OF VIETNAM VIETNAM LOVE not WAR

BLACK PANTHER PARTY

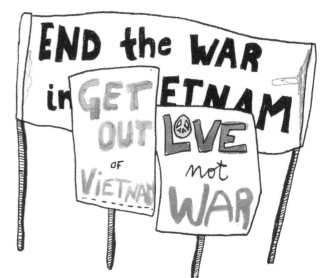

THE BLACK PANTHER PARTY WAS A REVOLUTIONARY BLACK NATIONALIST AND SOCIALIST ORGANIZATION FOUNDED BY BOBBY SEALE AND HUEY NEWTON IN OCTOBER 1966.

THE BLACK PANTHER PARTY MONITORED THE BEHAVIOR OF OFFICERS OF THE OAKLAND POLICE DEPARTMENT AND CHALLENGED POLICE BRUTALITY. THE ORGANIZATION ALSO MANAGED SOCIAL PROGRAMS, INCLUDING FREE BREAKFAST FOR CHILDREN PROGRAMS, AND COMMUNITY HEALTH CLINICS.

EVENTS IN THE UNITED STATES, INCLUDING THE FORMATION OF THE BLACK PANTHER PARTY, MADE DAVIS READY TO RETURN TO THE U.S.

DAVIS WORKED AS AN ASSISTANT PROFESSOR OF PHILOSOPHY AT THE UNIVERSITY OF CALIFORNIA. SHE WAS A SUPPORTER OF THE BLACK PANTHER PARTY AND LATER, JOINED THE COMMUNIST PARTY.

DAVIS WAS A VISIBLE PUBLIC FIGURE DURING THIS TIME AND ENDURED THREATS OF VIOLENCE BECAUSE OF HER RACE AND HER POLITICAL IDEAS.

IN THIS TURBULENT ATMOSPHERE THERE WAS **THE SOLEDAD BROTHERS CASE.**
THE SOLEDAD BROTHERS WERE THREE AFRICAN-AMERICAN INMATES, GEORGE JACKSON,
FLEETA DRUMGO, AND JOHN CLUTCHETTE, CHARGED WITH THE MURDER OF
A WHITE PRISON GUARD, JOHN VINCENT MILLS, AT CALIFORNIA'S SOLEDAD PRISON
ON JANUARY 16, 1970. IT WAS BELIEVED IN RETALIATION FOR THE SHOOTING
DEATHS OF THREE SEPARATE BLACK PRISONERS BY PRISON GUARD, OPIE G. MILLER
DURING A PRISON FIGHT.

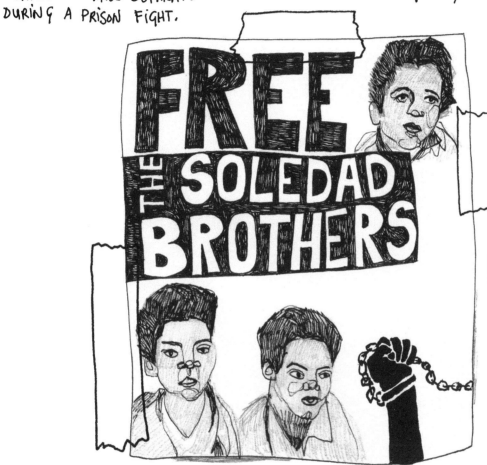

WELL KNOWN
PEOPLE LIKE
MARLON BRANDO,
NOAM CHOMSKY,
JANE FONDA,
ALLEN GINSBERG
AND ANGELA DAVIS
SUPPORTED
JACKSON, DRUMGO,
AND CLUTCHETTE.

DAVIS WENT TO THE PRISON TO MEET WITH GEORGE JACKSON.
ON THE 7TH OF AUGUST 1970, JACKSON'S BROTHER, JONATHAN JACKSON (17 YEARS OLD)
BURST INTO A COURTROOM DURING THE TRIAL. HE FREED THREE PRISONERS AND
TOOK THE JUDGE AND THREE JURORS AS HOSTAGES TO DEMAND THE RELEASE OF
"THE SOLEDAD BROTHERS". JONATHAN JACKSON, TWO OF THE PRISONERS, AND THE
JUDGE WERE SHOT DEAD.

DAYS LATER AUTHORITIES DETERMINED THE GUNS USED BY JONATHAN JACKSON
HAD BEEN BOUGHT BY DAVIS.

DAVIS WENT UNDERGROUND.

THE FBI ADDED DAVIS TO THE 10 MOST WANTED FUGITIVES LIST.

WANTED BY THE FBI

INTERSTATE FLIGHT - MURDER, KIDNAPING
ANGELA YVONNE DAVIS

Photograph taken 1969

FBI No. 867,615 G

Photograph taken 1970

Alias: "Tamu"

SHE WAS FINALLY ARRESTED IN NEW YORK CITY.

CHARGES:
- KIDNAPPING
- MURDER
- CRIMINAL CONSPIRACY

THE PROSECUTOR WANTED THE DEATH PENALTY FOR EACH OF THE THREE CHARGES.

DAVIS WAS PLACED IN SOLITARY CONFINEMENT IN WARD FOR PEOPLE WITH PSYCHOLOGICAL DISORDERS.

DURING THIS PERIOD OF TIME DAVIS HAD A MEETING WITH GEORGE JACKSON. THEY BEGAN TO WRITE PASSIONATE LETTERS TO EACH OTHER AND DEVELOPED A RELATIONSHIP. IN AUGUST 1971 GEORGE JACKSON GOT SHOT DURING AN ATTEMPTED PRISON ESCAPE.

MOBILIZATION SUPPORTING ANGELA SWELLED AROUND THE GLOBE. THE SONGS "SWEET BLACK ANGEL" BY THE ROLLING STONES AND "ANGELA" BY JOHN LENNON & YOKO ONO WERE DEDICATED TO DAVIS. NINA SIMONE CARRIED A BALLOON TO PRISON AND ANGELA FOUGHT TO KEEP IT WITH HER AS SHE WAS A BIG FAN OF THE SONGWRITER. BOB DYLAN WROTE THE SONG "GEORGE JACKSON" IN TRIBUTE TO THE BLACK PANTHER LEADER.

"DAVIS IS FREE ON BAIL!"

AFTER 16 MONTHS OF INCARCERATION, "THE NATIONAL UNITED COMMITTEE TO FREE ANGELA DAVIS AND ALL POLITICAL PRISONERS" (SHE INSISTED ON INCLUDING "ALL POLITICAL PRISONERS" IN THE NAME) GOT DAVIS RELEASED ON BAIL.

THE PRESUMPTION OF INNOCENCE HAD BEEN RESTORED.

THE PROSECUTOR OUTLINED A POLITICAL MOTIVE:

- DAVIS WAS A COMMUNIST AND A BLACK PANTHER SYMPATHIZER.
- SHE WORKED TO FREE THE SOLEDAD BROTHERS AND OTHER POLITICAL PRISONERS
- SHE DID THIS OUT OF REVOLUTIONARY FERVOR.

THE ROLLING STONES
SWEET BLACK ANGEL

Got a sweet black angel,
got a pin up girl,
got a sweet black angel,
up upon my wall.
Well, she ain't no singer
and she ain't no star,
but she sure talk good,
and she move so fast.
But the gal in danger,
yeah, de gal in chains,
but she keep on pushin',
would ya take her place?
she countin' up the days,
she's a sweet black angel, woh,
not a sweet black slave.

ON THE 4TH OF JUNE 1972 A WHITE JURY GAVE THE VERDICT.

- KIDNAPPING: "NOT GUILTY"
- MURDER: "NOT GUILTY"
- CRIMINAL CONSPIRACY: "NOT GUILTY"

THERE WAS **NEVER** A LEGAL CASE AGAINST ANGELA.

"This is the happiest day of my life"

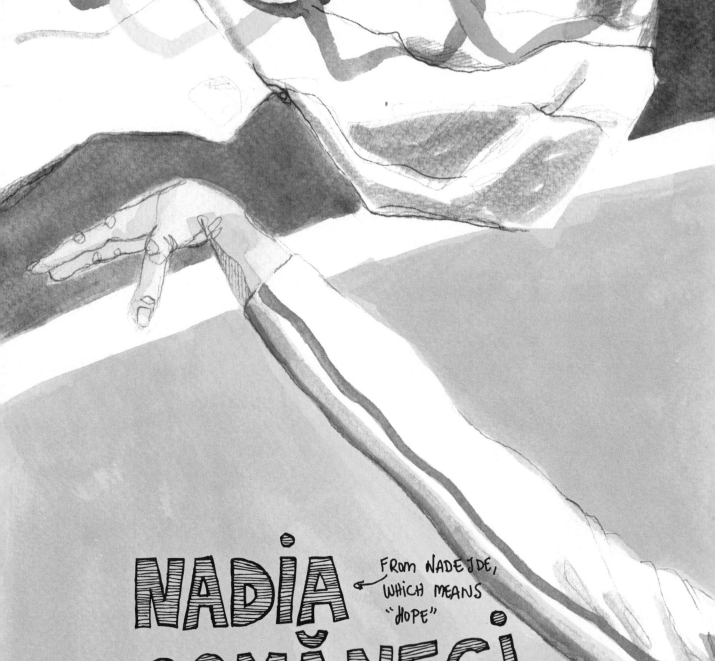

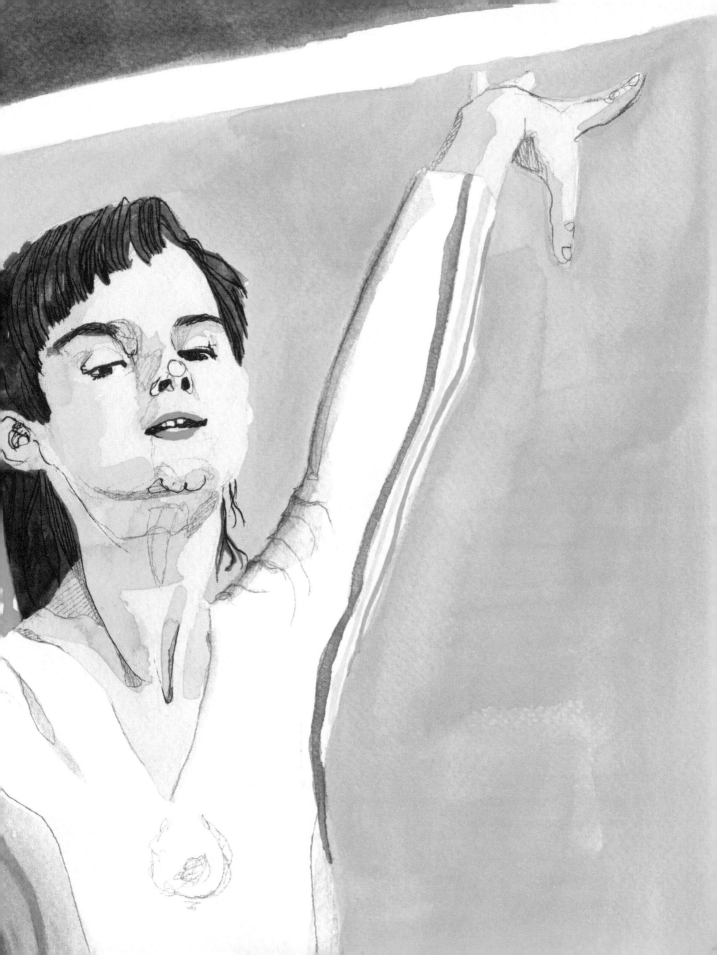

NADIA COMĂNECI WAS A RESPONSIBLE, HONEST, TENACIOUS AND TALENTED GIRL.
WHEN SHE WAS SIX A MAN WITH A BIG MOUSTACHE, BÉLA KÁROLYI, AND HIS WIFE, MARTA, ENTERED HER SCHOOL AND SAID:
 "WHO CAN DO A CARTWHEEL?"
ONLY TWO GIRLS RAISED THEIR HANDS.

COMĂNECI BECAME A MEMBER OF THE ROMANIAN ONEȘTI GYMNASTICS TEAM AND IN 1969 AT THE AGE OF NINE, NADIA COMPETED AT THE NATIONAL JUNIOR CHAMPIONSHIPS. SHE PLACED 13TH

COMĂNECI WAS DISPLEASED WITH THE COMPETITION RESULTS AND PROMISED NOT TO MAKE THE SAME MISTAKES ANYMORE.

THIS WAS THE BEGINNING OF COMĂNECI'S CAREER

COMĂNECI'S FIRST INTERNATIONAL SUCCESS: EUROPEAN WOMEN'S ARTISTIC GYMNASTICS CHAMPIONSHIPS, SKIEN, NORWAY.

1976 SUMMER OLYMPICS, MONTREAL

ON THE 18TH OF JULY NADIA MADE HISTORY ON THE UNEVEN BARS.
SHE BECAME THE FIRST GYMNAST TO BE AWARDED A PERFECT SCORE IN AN OLYMPIC GYMNASTIC EVENT. COMĂNECI WAS JUST 14 YEARS OLD. SHE GOT 6 ADDITIONAL TENS IN COMPETITION, AND WON THREE GOLD, ONE SILVER AND ONE BRONZE MEDALS.
DURING THE OLYMPICS, NADIA ATE PIZZA, CEREAL BREAKFAST, AND PEANUT BUTTER FOR THE FIRST TIME IN HER LIFE.

THE ELECTRONIC SCOREBOARD INSTALLED IN MONTREAL LACKED THE SPACE NEEDED TO ACCOMMODATE ALL FOUR FIGURES TO ILLUSTRATE THE PERFECT MARK.
EVERYONE THOUGHT IT WAS A MISTAKE, BUT IT MEANT 10. SCORE OF PERFECT 10!!

COMĂNECI BECAME FAMOUS ALL OVER THE WORLD. WHEN SHE RETURNED HOME, SHE WAS A NATIONAL HERO.
IN 1976 ROMANIA WAS GOVERNED UNDER COMMUNIST DICTATORSHIP. NICOLAE CEAUȘESCU, THE GENERAL SECRETARY OF THE ROMANIAN COMMUNIST PARTY, USED SPORT ACHIEVEMENTS FOR PROPAGANDA PURPOSES. HE AWARDED COMĂNECI WITH THE SICKE AND HAMMER GOLD MEDAL AND NAMED HER A HERO OF SOCIALIST LABOR. SHE WAS A SYMBOL OF PERFECTION.

CEAUȘESCU SENT NADIA TO BUCHAREST TO SEPARATE HER FROM KÁROLYI. CEAUȘESCU NEVER LIKED THE FACT THAT KÁROLYI HAD HUNGARIAN BLOOD. HE WANTED COMĂNECI'S TRAINERS TO BE PURE ROMANIANS. THIS DECISION MADE NADIA VERY UNHAPPY.

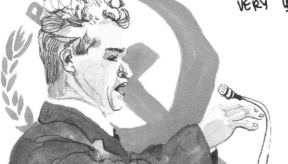

THE FALL

WHEN SHE LIVED IN BUCHAREST, COMĂNECI REDUCED HER TRAINING REGIMEN. SHE WAS LIVING UNDER SUPERVISION OF THREE GUARDS WHO MONITORED HER ACTIVITIES. IT WAS VERY DIFFICULT FOR HER TO ADAPT AND TRAIN.

EVEN THOUGH NADIA HAD GROWN IN HEIGHT, WASN'T FIT, AND GAINED WEIGHT, CEAUȘESCU ASKED KÁROLYI TO COME BACK AND TRAIN HER FOR THE WORLD CHAMPIONSHIPS IN STRASBOURG 1978. COMĂNECI DIDN'T GIVE UP AND ACCEPTED THE CHALLENGE. SHE FELL FROM THE UNEVEN BARS DROPPING TO THE 4TH PLACE. SHE DID WIN THE WORLD TITLE ON BEAM, AND A SILVER MEDAL ON VAULT. THE MEDIA SAID IT WAS THE END OF NADIA.

☆ COMĂNECI'S STRENGTH ☆

NADIA WAS A FIERCE COMPETITOR. AFTER HER PERFORMANCE IN THE 78 WORLD CHAMPIONSHIPS IN STRASBOURG SHE WANTED TO SHOW THE WORLD THAT SHE COULD STILL COMPETE AND WIN. IN 1979 COMĂNECI WON HER THIRD CONSECUTIVE EUROPEAN ALL-AROUND TITLE IN COPENHAGEN. SHE WAS THE FIRST GYMNAST (MALE AND FEMALE) TO REACH THIS FEAT. DURING A COMPETITION TOUR IN U.S. IN 1981 WITH THE ROMANIAN GYMNASTICS FEDERATION, KÁROLYI WAS ACCUSED OF CRITIZING CEAUȘESCU AND HIS REGIME. KÁROLYI AND HIS WIFE DECIDED TO DEFECT TO AVOID PUNISHMENT AND POSSIBLY PRISON.

DURING THIS TIME COMĂNECI WAS UNDER CONSTANT VIGILANCE. THE GOVERMENT WAS AFRAID OF HER POSSIBLE DEFECTION TOO.

NADIA RETIRED FROM GYMNASTICS WHEN SHE WAS 24. ON THE 27TH OF NOVEMBER OF 1989 SHE ESCAPED FROM ROMANIA. SHE WAS WELCOME AT THE JFK AIRPORT IN NY, AMERICA, WHERE SHE CURRENTLY LIVES. FINALLY FREE!!

SEVERAL WEEKS AFTER COMĂNECI'S DEFECTION THE ROMANIAN REVOLUTION STARTED, NICOLAE CEAUȘESCU AND HIS WIFE, ELENA, WERE EXECUTED.

COMĂNECI IS STILL INVOLVED WITH THE OLYMPIC GAMES. SHE DOES CHARITY WORK AND MANAGES THE NADIA COMĂNECI CHILDREN'S CLINIC, WHICH PROVIDES LOW-COST AND FREE MEDICAL AND SOCIAL SUPPORT TO ROMANIAN CHILDREN.

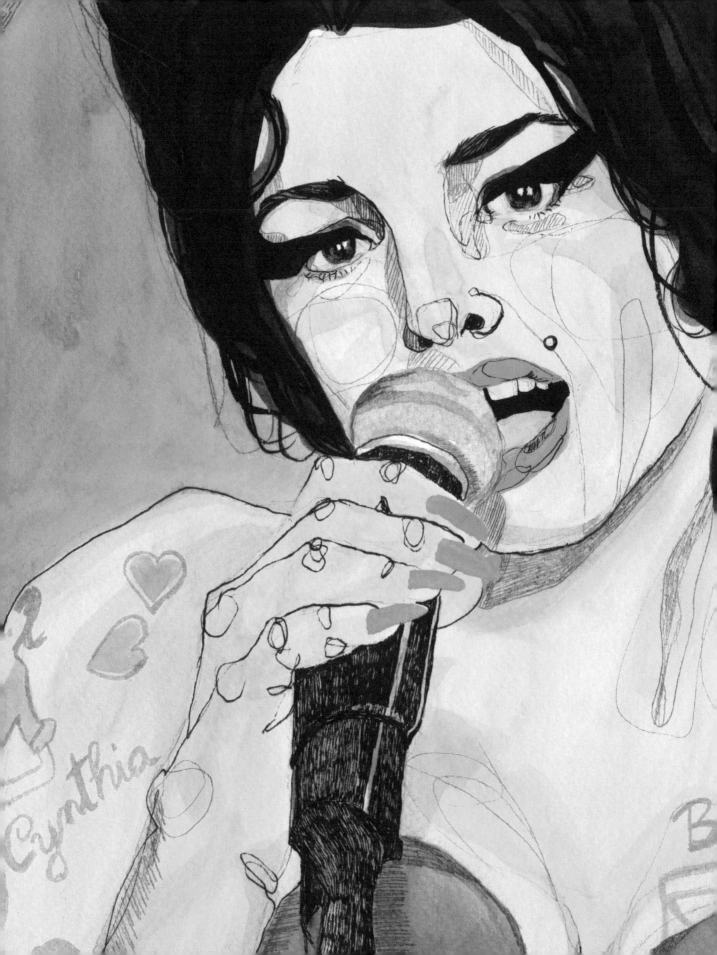

AMY WINEHOUSE

14TH SEPTEMBER 1983, LONDON, ENGLAND —
23RD JULY 2011, LONDON, ENGLAND

AMY WINEHOUSE WAS BORN TO A JEWISH FAMILY IN SOUTHGATE, LONDON, IN 1983. HER PARENTS, MITCHELL, A TAXI DRIVER, AND JANIS, A PHARMACIST, PASSED THEIR LOVE FOR SOUL & JAZZ ON TO HER. MANY OF WINEHOUSE'S MATERNAL UNCLES WERE PROFESSIONAL JAZZ MUSICIANS.

CAMDEN LOCK

AT A YOUNG AGE IT WAS CLEAR WINEHOUSE LIKED SINGING MORE THAN SCHOOL. WHEN SHE WAS 10 SHE FOUNDED A RAP BAND CALLED "SWEET 'N' SOUR" WITH HER BEST FRIEND.

WHO IS THAT GIRL WITH THE JAZZY BLUESY VOICE??

FRANK

NAMED AFTER FRANK SINATRA

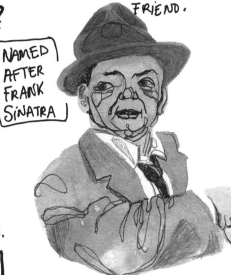

WINEHOUSE'S DEBUT ALBUM LAUNCHED IN 2003. IT HAD CLEAR INFLUENCES FROM JAZZ. THE ALBUM WENT PLATINUM AND ESTABLISHED HER SINGING CAREER.

THE FIRST THING WINEHOUSE DID WITH HER ALBUM ROYALTIES WAS BUYING A HOUSE IN HER FAVOURITE NEIGHBOURHOOD IN LONDON, CAMDEN.

GLASTONBURY WAS WINEHOUSE'S FIRST MUSIC FESTIVAL. TODAY THE FESTIVAL IS ATTENDED BY 175,000 PEOPLE.

WINEHOUSE'S SECOND ALBUM "BACK TO BLACK" WAS RELEASED IN 2006. IT WAS AN INTERNATIONAL SUCCESS. SHE RECEIVED SIX GRAMY NOMINATIONS AND WON FIVE GRAMMYS.
WHEN WINEHOUSE WAS WORKING ON THE ALBUM HER LOVER, BLAKE FIELDER-CIVIL, BROKE HER HEART. THAT EXPERIENCE WAS THE INSPIRATION FOR THE LYRICS FOR "BACK TO BLACK."

WINEHOUSE LOVED GOING TO POLL HALLS

we only said goodbye with words
I died a hundred times
you go back to her
and I go back to
I go back to us

WINEHOUSE FELT "BACK TO BLACK" WAS A PERSONAL SONG. IT MADE HER CRY WHEN SINGING IT. LISTENING TO THESE SHARP VERSES IT SEEMS OBVIOUS THAT SHE WASN'T THE ONLY ONE CRYING.

They tried to make me go to rehab but I said no, no, no
Yes I've been black but when I come back you'll know, know, know
I ain't got the time and if my daddy thinks I'm fine
he's tried to make me go to rehab but I won't go, go, go

"REHAB" WAS THE LEAD SINGLE FROM "BACK TO BLACK".

Daddy's

AFTER WINEHOUSE'S BREAK UP WITH BLAKE SHE WAS IN A VERY TOUGH PLACE. SHE DRANK A LOT. AMY TRANSFORMED HER REALITY INTO LYRICS.

Cynthia HER GRANDMA

Girl WINEHOUSE'S DISTINCTIVE APPEARANCE AND HER CARELESS ATTITUDE WHEN TALKING TO THE MEDIA LED TO HER BEING HOUNDED BY THE PRESS DAY AND NIGHT. THIS MEDIA FRENZY HOWEVER, SPARKED DEVOTION TO WINEHOUSE FROM YOUNG FANS.

"I'm quite an insecure person, I'm very insecure about the way I look. I mean, I'm a musician I'm not a model. The more insecure I felt, more I'd drink. (...) The more insecure I feel, the bigger my hair has to be"

BEEHIVE HAIRDO

I TOLD YOU i WAS TROUBLE

WINEHOUSE'S ADDICTION TO DRUGS AND ALCOHOL AND HER SELF-DESTRUCTIVE BEHAVIOR WAS BIG NEWS AND SOLD NEWSPAPERS.

"Today's papers are just tomorrow's fish & chips paper so it doesn't bother me"

LOVE iS A LOSING GAME

AMY AND BLAKE GOT BACK TOGETHER AND IN MAY OF 2007 WINEHOUSE MARRIED HIM. FOLLOWING THEIR MARRIAGE, HE GOT ARRESTED FOR GRIEVOUS BODILY HARM WITH INTENT. BLAKE FIELDER-CIVIL WOULD ADMIT BEING THE ONE IN INTRODUCING WINEHOUSE TO CRACK, COCAINE AND HEROIN.

ON SATURDAY 23TH JULY 2011 WINEHOUSE WAS FOUND DEAD ON HER BED. BLOOD ALCOHOL CONTENT (BAC) WAS FOUR TIMES THE BAC LEVEL PERMITTED TO DRIVE. SHE WAS 27 YEARS OLD. FRAGILE AND STRONG, WINEHOUSE LEFT THE BEST GIFT SHE COULD GIVE US, HER MUSIC.

117

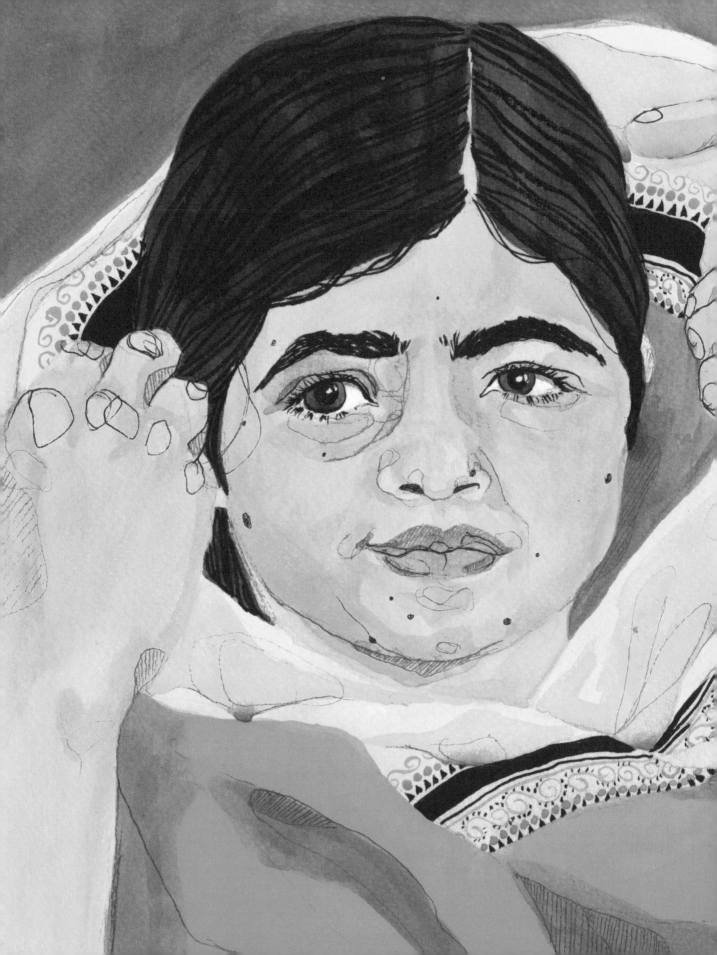

MALALA YOUSAFZAI

12TH JULY 1997, MINGORA, SWAT DISTRICT, PAKISTAN

MALALA YOUSAFZAI IS A HUMAN RIGHTS ADVOCATE BEST KNOWN
FOR HER WORK AGAINST THE SUPPRESSION OF CHILDREN AND YOUNG PEOPLE
AND FOR THE RIGHT OF ALL CHILDREN TO AN EDUCATION.
HER STORY GAINED INTERNATIONAL RECOGNITION THANKS TO JOURNAL ENTRIES
SHE WROTE FOR THE BRITISH BROADCASTING CORPORATION (BBC) ABOUT HER LIFE
DURING THE TALIBAN OCCUPATION OF SWAT VALLEY IN NORTHWEST PAKISTAN.

SHE WAS 12 YEARS OLD AND USED THE PSEUDONYM GUL MAKAI.

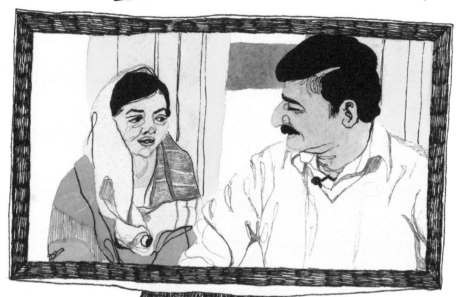

* MALALA WITH HER FATHER, ZIAUDDIN YOUSAFZAI,
A POET, SCHOOL OWNER AND EDUCATIONAL ACTIVIST
IN THE DOCUMENTARY "CLASS DISMISSED: MALALA'S STORY"

THE TALIBAN IS A SUPPRESSIVE SUNNI ISLAMIC FUNDAMENTALIST POLITICAL
MOVEMENT. TV AND MUSIC WERE FORBIDDEN, THE TALIBAN EXECUTED PEOPLE
IN THE STREETS, AND THEY CLOSED SCHOOLS IN FAVOR OF RELIGIOUS SCHOOLS
CALLED MADRASAS, WHICH TAUGHT STRICT FUNDAMENTALIST ISLAMIC LAW.
THE TALIBAN BANNED EDUCATION FOR GIRLS BETWEEN 2003 AND 2009.

"After January 15TH (2009) girls must not go to school.
Otherwise, the guardians and the school will be responsible"

50,000 SCHOOL GIRLS WOULD LOSE THEIR EDUCATION RIGHT.
MOST OF YOUSAFZAI'S SCHOOLMATES LEFT THE SCHOOL BUT MALALA KEPT
STUDYING AND PURSUED HER EDUCATION. SHE HID HER BOOKS AND STOPPED
WEARING HER SCHOOL UNIFORM.
SHE WROTE THE LETTERS TO A JOURNALIST WHO WAS ABLE TO SCAN THEM
AND SEND THEM BY EMAIL TO THE BBC.

IN THE SUMMER OF 2009, NEY YORK TIMES JOURNALIST ADAM B. ELLICK FILMED A <u>DOCUMENTARY</u> ABOUT MALALA YOUSAFZAI ENTITLED "CLASS DISMISSED: MALALA'S STORY".
YOUSAFZAI USED HER STANDING ON THE INTERNATIONAL STAGE TO PROMOTE THE <u>RIGHT TO EDUCATION.</u>

SHE WAS NOMINATED FOR THE INTERNATIONAL CHILDREN'S PEACE PRIZE OF THE KIDSRIGHTS FOUNDATION AND AWARDED WITH PAKISTAN'S FIRST NATIONAL YOUTH PEACE PRIZE.

MURDER ATTEMPT

ON THE 9TH OF OCTOBER 2012 A TALIBAN GUNMAN <u>SHOT</u> YOUSAFZAI IN THE HEAD WHEN SHE WAS RETURNING HOME IN A BUS FROM SCHOOL. SHE WAS <u>16 YEARS OLD.</u> TWO MORE STUDENTS WERE INJURED IN THE ATTACK. YOUSAFZAI WAS AIRLIFTED TO A MILITARY HOSPITAL IN PESHAWAR AND ON THE 15TH OF OCTOBER SHE WAS TRANSPORTED TO A HOSPITAL IN BIRMINGHAM, UK, FOR HER SAFETY AND FURTHER TREATMENT. AFTER WAKING UP FROM AN INDUCED COMA MALALA WAS DISCHARGED ON THE 4TH OF JANUARY 2013. THE ATTACK RECEIVED <u>INTERNATIONAL CONDEMNATION.</u>

SINCE THEN MALALA HAS BEEN SUPPORTING CAMPAIGNS IN FAVOUR OF CIVIL RIGHTS, ESPECIALLY WOMEN AND CHILDREN RIGHTS.

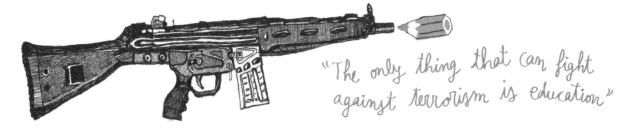

"The only thing that can fight against terrorism is education"

IN 2014, SHE WAS AWARDED WITH THE <u>NOBEL PEACE PRIZE</u> TOGETHER WITH KAILASH SATYARTHI FOR THEIR <u>ACTIVISM AGAINST THE SUPPRESSION OF CHILDREN AND FOR THE RIGHT OF ALL CHILDREN TO AN EDUCATION.</u> MALALA BECAME THE <u>YOUNGEST</u> PERSON TO RECEIVE THE PEACE PRIZE IN ANY CATEGORY. SHE WAS <u>17 YEARS OLD.</u> YOUSAFZAI HAS RECEIVED MANY AWARDS AND HAS BEEN CHOSEN BY "TIME" MAGAZINE AS ONE OF THE 100 MOST INFLUENTIAL PEOPLE IN THE WORLD IN THE YEARS 2013, 2014 AND 2015.

"One child, one teacher, one book, one pen can change the world"

121

Women inventors

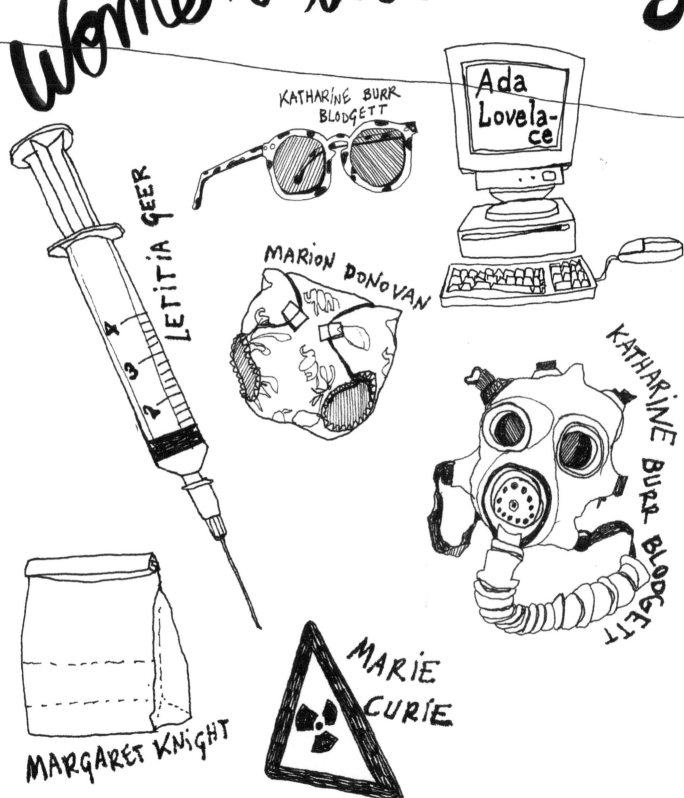

and discoverers

RUTH WAKEFIELD

STEPHANIE KWOLEK

KEVLAR

HEDY LAMARR

MARY PHELPS JACOB

PATRICIA BATH

LILLIAN MOLLER GILBRETH

ALICE GUY

DOCUMENTATION

NATIONAL GEOGRAPHIC.COM, BBC.CO.UK, NYTIMES.COM, WIKIPEDIA.COM
EDITION.CNN.COM, BLETCHLEYPARKRESEARCH.CO.UK

BIBLIOGRAPHY

"A HISTORY OF THEIR OWN: WOMEN IN EUROPE FROM PREHISTORY TO THE PRESENT." VOL.1/VOL.2. BONNIE S. ANDERSON & JUDITA ZINSSER. 1988

"FRIDA: A BIOGRAPHY OF FRIDA KAHLO." HAYDEN HERRER. 2002

"HISTORIAS DE MUJERES". ROSA MONTERO. 2007

"WITCHES, MIDWIVES, AND NURSES". DEIRDRE ENGLISH & BARBARA EHRENREICH. 2010

DOCUMENTARIES AND FILMS

"CLASS DISMISSED: MALALA'S STORY". ADAM B. ELLICK. 2010
"THE BLACK POWER MIXTAPE 1967-1975". GÖRAN OLSSON. 2011
"FREE ANGELA AND ALL POLITICAL PRISONERS". SHOLA LYNCH. 2012
"AMY". ASIF KAPADIA. 2015
"NADIA COMĂNECI: THE GYMNAST AND THE DICTATOR", POLA RAPAPORT, 2016
"MUJERES EN LA HISTORIA" DOCUMENTARIES. RTVE

"GORILLAS IN THE MIST: THE STORY OF DIAN FOSSEY". MICHAEL APTED. 1988
"FRIDA". JULIE TAYMOR. 2002
"AMELIA". MIRA NAIR. 2009
"THE DANISH GIRL". TOM HOOPER. 2015
"LA DANSEUSE". STÉPHANIE DI GIUSTO. 2016

ACKNOWLEDGEMENTS

TO JANDRO, FOR HIS HELP AND, ABOVE ALL, FOR BELIEVING IN ME MORE THAN I DO MYSELF.

TO ISA, CRISTI, NURIA AND EVA, FOR THEIR FRIENDSHIP AND EVERY SINGLE SMILE.

TO MY PARENTS, MY BROTHER AND MY FAMILY, FOR THEIR SUPPORT.

TO LIT RIOT PRESS, FOR GIVING ME THE OPPORTUNITY OF MAKING THE BOOK I WANTED TO MAKE.

TO ALL THE WOMEN WHO APPEAR IN THIS BOOK, FOR KEEPING ME COMPANY ON THIS JOURNEY.

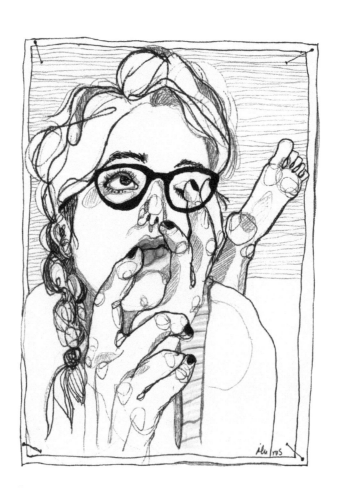

ILU ROS

ARTIST ILU ROS HAS A DUAL BACHELOR'S DEGREES IN FINE ARTS
AND MEDIA COMMUNICATION FROM THE UNIVERSITY OF GRANADA, SPAIN.
SHE ENJOYS EXPERIMENTING IN SEVERAL ARTISTIC DISCIPLINES.
HER ARTISTIC REFERENCES ARE DIVERSE, INCLUDING CONTEMPORARY
ARTISTS SUCH AS BILL VIOLA, TRACEY EMIN, LOUISE BOURGEOIS,
AND EGON SCHIELE.

ILU LOVES WATCHING AND DRAWING PEOPLE, IMAGINING AND REIMAGINING
THEIR DAILY LIVES. MOST OF ILU'S DRAWINGS AND PAINTINGS ARE MADE
WITH WATERCOLOR, GRAPHITE, INK, MARKERS, AND ACRYLICS, ON PAPER.
THESE ARE THE TOOLS THAT ALLOW HER TO WORK QUICKY, CATCHING
THE SPONTANEITY OF THE ELEMENTS AND PEOPLE SHE WANTS TO DRAW.

ROS CURRENTLY LIVES IN LONDON, ENGLAND, WHERE SHE WORKS AS
A FREELANCER. SHE IS WORKING ON SEVERAL PROJECTS INCLUDING
"I LIVE IN A COUNCIL FLAT", ABOUT THE COUNCIL BLOCKS IN LONDON
AND SURROUNDING BOROUGHS, AND HAS COMPLETED HER FIRST
ILLUSTRATED BOOK, "HEY SKY, I'M ON MY WAY: A BOOK ABOUT
INFLUENTIAL WOMEN".

CONNECT WITH ILU:
 WWW.ILUROS.COM
 @ILUROS

Lightning Source UK Ltd.
Milton Keynes UK
UKHW051026191120
373637UK00004B/81